FLOWERS FROM A PAINTER'S GARDEN

The watercolors of
PAUL GELL

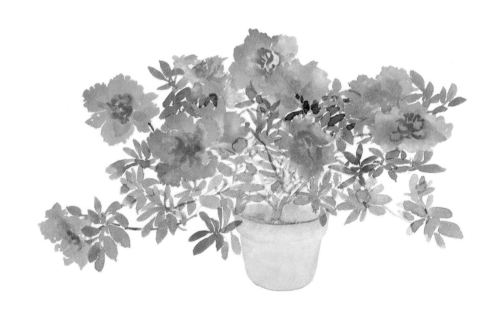

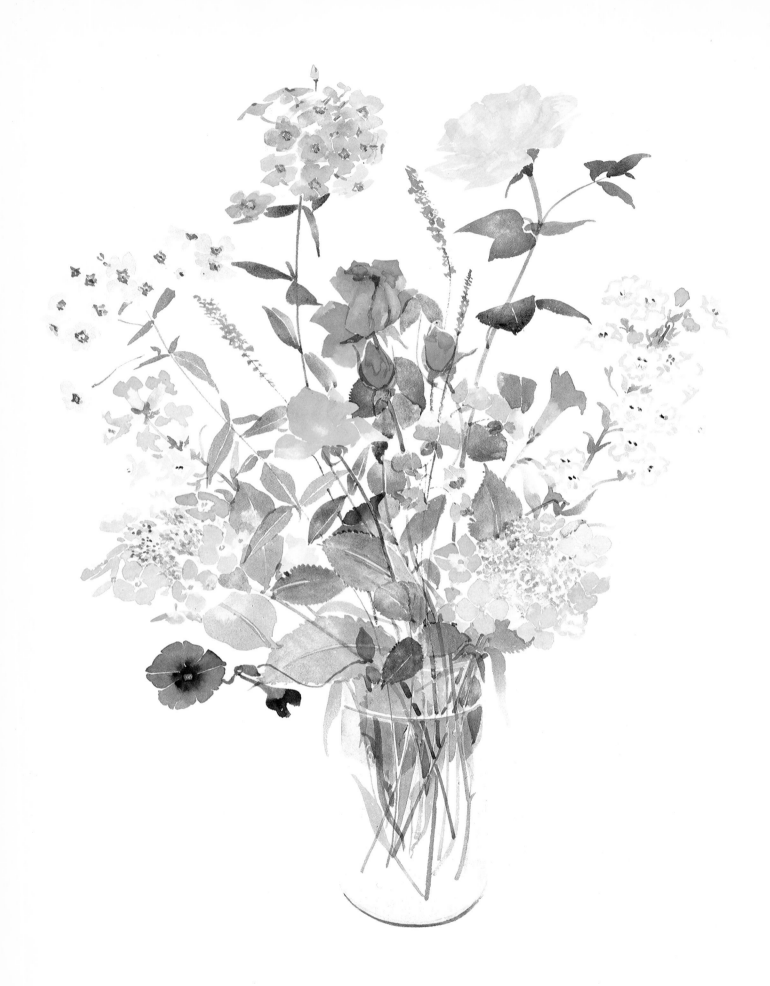

FLOWERS FROM A PAINTER'S GARDEN

The watercolours of

PAUL GELL

With commentaries by the artist
Botanical notes by
RONALD KING

WEIDENFELD AND NICOLSON LONDON

For Faith Powys
and Phyllis Gray

First published by George Weidenfeld and Nicolson Limited
91 Clapham High Street London SW4
ISBN 0 297 78204 5

Colour separations by Newsele Litho Ltd
Printed by L.E.G.O., Vicenza, Italy

LIST OF PAINTINGS

Spring

1 Just Anemones 2 Polyanthus – Trumpet Spring 3 Spring Mauves 4 Daffodil Mix
5 Spring Tricolour 6 Bright Bouquet 7 Prunus – Pink Finale 8 Opening Reds
9 Easter Day 10 Pansies Startled 11 Bearded Iris and Clematis Entwine
12 Nellie Moser's Annual Frolic 13 Early May 14 Irises – Drama for May
15 Wisteria in Breeze 16 Laburnum – Golden Rain 17 Signals for Summer

Early Summer

18 Early Summer in the Wild Garden 19 Digitalis Pink 20 Cornflowers Twice
21 Colours Sweetly Clashing 22 Poppies – Zenith 23 Roses With Weigela
24 Everlasting Pea 25 Rosa Mundi with Sweet Peas 26 Wild Garden Fantasy
27 Perpetual Carnations 28 Poppy Mix 29 Lilies and Corn Marigolds
30 Sweet Peas – First Cutting 31 Poppies – Deep Purple

High Summer

32 Single Peonies 33 Lupins and Day Lilies 34 Lavatera – Splendidly Pink
35 China Roses 36 Balloon Flowers – Opening 37 Morning Glory
38 Lupins – Punky Pinks 39 Portland Roses 40 Bouquet for Bakst
41 High Summer Flowers with White Begonia 42 Phlox – Changing Pinks
43 Hot Summer Mix 44 Lacecaps – A Pinker Pink 45 Gladioli – Flame Flamboyant

Autumn

46 Lilium Speciosum Var. Rubrum 47 Blue Hibiscus 48 Dahlias – Red and Fiery
49 From a Cottage Garden 50 Fuchsia Magellanica 51 Blue Hydrangeas
52 Sunflowers – Burning Bright 53 Belladonna – Softly Pink 54 Pelargonium Mix
55 Yellow Corner 56 First Opening – Freesias 57 Glinting Gold
58 Autumn's Hanging Blossoms and Honesty 59 Golden Lights

Winter

60 Cyclamen – Big and Bold 61 Harlequin Mix 62 Eastern Azalea
63 Poinsettia – E. Pulcherrima 64 Hellebores in Midwinter 65 Pale and Paler Camellias
66 Acacia Sunshine 67 Sweet Almond 68 Spring is Coming

INTRODUCTION

The paintings in this volume were selected to show the garden's flowering through a typical twelve month and are grouped within seasons to present the changing quality of their colours throughout the year. In spring there is a particular clarity and purity of colour that is close to translucency, while summer flowers are saturated with trenchant colour. Autumn brings richness and a depth of hue that suggests the petals are coated with pigment. Winter's blossoms have least intensity, their fugitive tints have a drained look.

In my paintings the portrayal of light and space is as important as the subject. Nature provides the inspiration – flowers and plants are the basic pictorial elements – but painterly considerations govern the placing of the images on the paper. The way the colour is employed is not merely descriptive but is selected for colour balance, to give spatial recession and to provide tonal dissonance. Flowers have an inherent presence and personality and it is their essence I set out to communicate. Each finished work must stand as a painting in its own right rather than being a botanical portrait.

The plants that grow in my garden are very varied. It is a chalk garden on a peninsula jutting into Plymouth Sound, with a perimeter that is partly rocky outcrop and partly old stone walls enclosing steep and flat areas, some exposed, others protected. The gardens I enjoy most are a happy compromise between man and nature, planning and accident, and this predilection governs the changes I have made to the original layout. In five areas separated by high walls are a vegetable and herb garden, a fruit garden, a formal garden to the east with a belvedere looking on to the ocean, a west garden with red borders, and on the south side a wild garden. Taking over the garden was a challenge as it was largely overgrown. Fortuitously there were many established plants including several specimen shrubs such as Pittosporum and Japanese Maples. New planting has included many tender varieties and perennial flowers as I like to see old friends reappearing year after year.

The garden encloses the house. Look through any window or step out of any door and nature is immediate. Life in this house is a constant, intimate relationship with the surrounding plants and trees. Curiously, this daily acquaintance with the garden has meant no end of visual stimulation. Looking time after time even at the most familiar plants increases my understanding and reveals surprisingly different aspects — the things to be discovered and seen anew appear to be infinite.

It is the constant flux of the life force in every plant that I respond to. This continuous sense of movement, however imperceptible, is what I set out to portray and it demands the least rigid of all media, watercolour. Watercolour makes possible effects that are both transparent and opaque and allows degrees of delineation and suggestion to flow unhindered from the brushes. Also important is the ability to make shapes without abrupt edges or hard lines, which is necessary when describing many kinds of petals and expressing forms that appear to melt into space.

My way of working is direct, there is no preliminary drawing. I always work standing up with the paper flat at table height, a method that requires a medium of maximum fluidity and facility in order to make the marks I want instantly. I paint by setting down the essential shapes rather than employing washes and working over them. An approach alien to more orthodox European watercolour techniques and closer to the traditional way in which Chinese and Japanese artists work. Flowers and plants are either painted growing or cut. When cut, they are never made into formal arrangements, but individual flowers are simply put in jars and dotted all round the studio. Often, they are set on a 'lazy Susan', which I keep turning so the viewpoint constantly varies. The studio stands alone in a small courtyard, a marvellous arrangement that means complete quiet with no intrusions. It is a place where it is possible to be completely engrossed in painting and wholly absorbed in the contemplation of the flowers.

JUST ANEMONES

Every year the anemones stun me with fresh surprise. Tight buds in the garden, once indoors they explode into cups of unbelievable colour. There is such excitement in seeing the flowers change as their petals unfold. Some end up as flat as saucers, displaying as they open intricate centres that are each quite individual.

Anemone coronaria, the Poppy Anemone, is native to the Mediterranean area and Asia Minor. The genus is placed in the family *Ranunculaceae*, being allied to the buttercups after which that family is named. The name itself is derived from the Greek *anemos*, which means 'wind'. The epithet *coronaria* means 'crown' or 'wreath-like', so that the whole describes the plant as 'the wind-flower with crown-like blossoms'. *A. coronaria* grows from a curiously shaped flattish black rhizome, often referred to as a 'claw'. The long-stalked leaves spring straight from the rhizome and the plant thus hugs the ground, rising to a height of six to twelve inches only. It has been cultivated in gardens since ancient times, innumerable varieties having been bred from it.

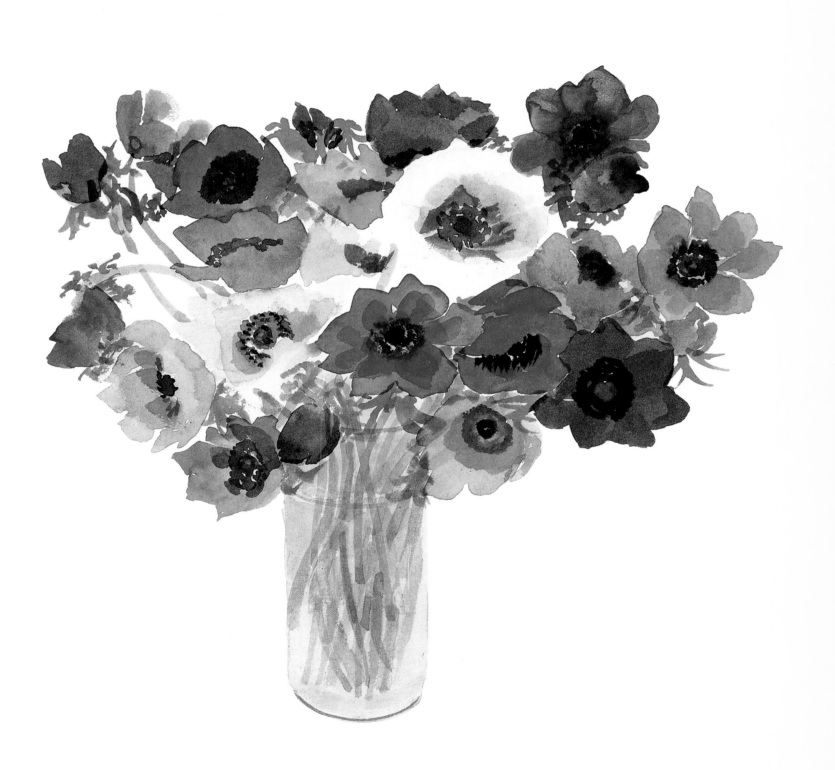

POLYANTHUS – TRUMPET SPRING

Polyanthuses bring the year's first bright colours: hard, clear shades of magenta, crimson, purple, uncompromising blue and hot yellow. Stiffly flowering on sturdy stalks, they bloom in clusters that magnify their colours. Right from their first appearance their impact is tremendous. Looked at closely, the flowers reveal pronounced patterning with well-marked centres in surprising contrasts of colour — a contrast often repeated in the margins outlining each petal. The arbitrary detailing is suggestive of a floral heraldry.

The polyanthus that we grow in our gardens is botanically a protean entity that cannot be pinned down to a particular species. In it are elements of *Primula vulgaris*, the primrose, and *Primula veris*, the cowslip, that, unlike the primrose, carries its flowers in an umbel several to the stem, a characteristic that it has passed on to the polyanthus. In it also is *Primula elatior*, the oxlip, which resembles the cowslip but has larger flowers. The generic name *Primula* is derived from the Latin *primus*, meaning 'first', and refers to its habit of early flowering.

SPRING MAUVES

Purple mauves lit with yellow — anemones, hellebores and freesias in conjunction look unseasonably exotic. The deep, dark shades of the anemones sound a barbaric note. That they should combine such velvety, purple-black centres with white crêpe paper petals is unexpected and nearly appears artificial. Strangely, most of the early mauves do look as if the flowers have been coloured with ink — there's a brittle, dyed look about them whether pale or dark.

All the plants included in the genus *Anemone* are hardy perennials, most of them being very ornamental. Some have broadly lobed leaves, but those of *A. coronaria* are finely divided. The flowers of this species as it grows in the wild are very variable in colouring, shades of mauve being only one of the many colours in which it may be found. The seeds are covered in a mass of cotton-like down which adheres closely to them. This makes the individual seeds difficult to separate from one another for sowing in cultivation, but facilitates carriage far afield by the wind in nature, so that in spring the plant is able to transform the barrenness of its native southern European hills and valleys into a blaze of colour.

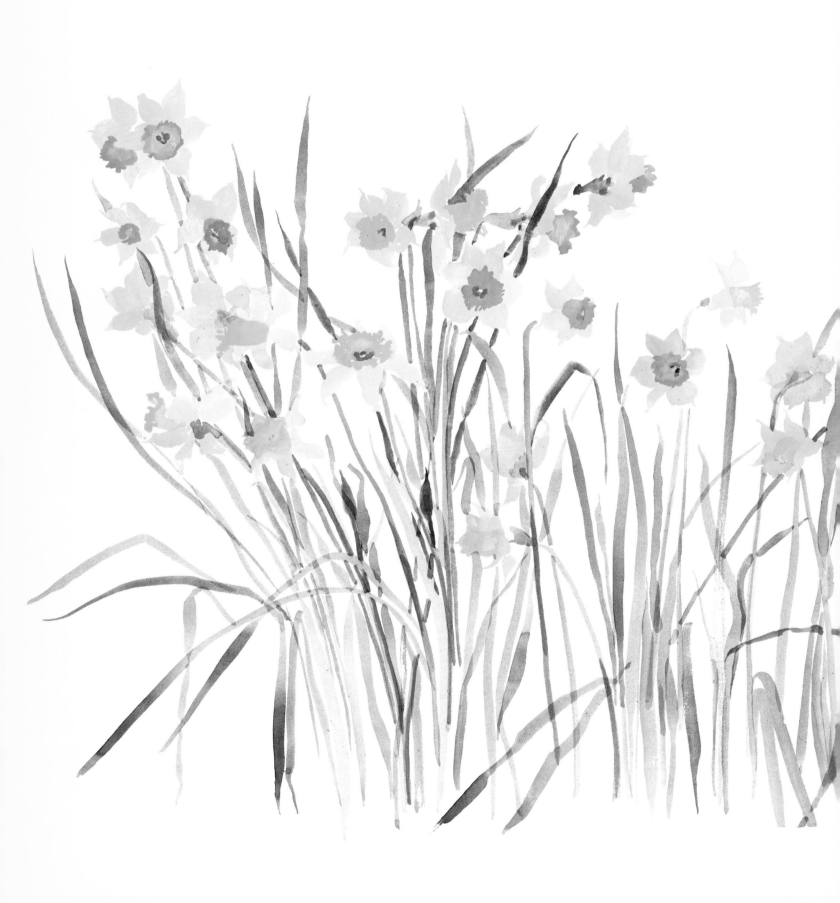

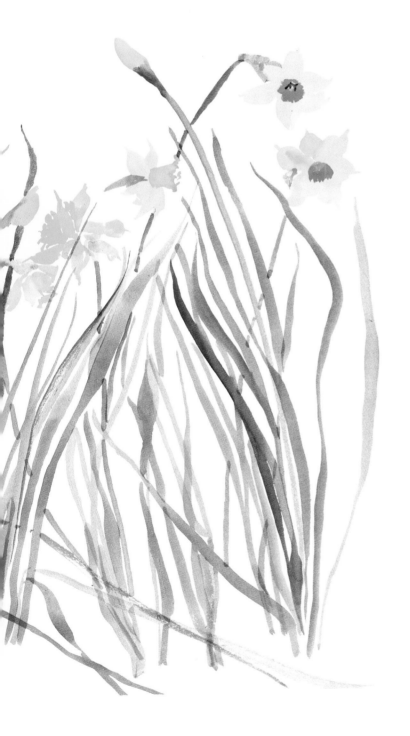

DAFFODIL MIX

Say 'daffodils' and it immediately conjures Wordsworthian images, visions of massed plants with green blade-like leaves and nodding yellow flowers. The huge narcissi family comprises many varieties and is still expanding enormously. New strains produce different sizes and shapes, with endless permutations in the scale and relationship of the characteristic cup and petals. Cultivated in every shade of yellow, orange and white, all open into flowers of startling brightness, whether self-coloured or with contrasting cup and petals. Their flowering is like galaxies of stars shining out to herald spring.

Daffodils and narcissi, which are regarded popularly as two different kinds of flower, are not botanically separate: all are part of the genus *Narcissus* belonging to the family *Amaryllidaceae*. The daffodils with large flowers and a central trumpet are varieties or hybrids of the species *Narcissus pseudo-narcissus*. The generic name *Narcissus* comes from the Greek word *narkan* which means 'to stupefy', both the scent of the flowers and the substances found in them being thought to possess narcotic properties. The word 'narcotic' is itself derived from the same root.

SPRING TRICOLOUR

Although mostly familiar as the florist's iris, the Dutch varieties are actually easy to grow. In the garden their distinctive knitting needle foliage is decorative and different. The flowers, in contrast to other irises blooming at the same time, have a delicate appearance and a more compact silhouette due to their crisper petals. Most commonly blue, there are also yellow and white varieties, all embellished with bright yellow chenille-like beards. Excellent for cutting, they are especially good mixers.

The Dutch Iris is a hybrid of *Iris xiphium* var. *praecox*, the early flowering variety of the Spanish Iris, and *I. tingitana*, the Tangier Iris. 'Iris' means 'many-coloured', but the reason for the use of *xiphium* in the name is not known; *tingitana* means 'of Tangier'. The Darwin Tulip, of complex hybrid origin, was first put on the market by Jules Lenglart in 1886. Its name honours the famous biologist Charles Darwin. It is considered by many the most beautiful, and is probably the most popular, of all garden hybrid tulips. The narcissus represented is *Narcissus poeticus*, the Poet's Narcissus, a native of southern Europe and the latest to bloom of all the spring-flowering narcissi. Its name derives from the fact that, because of the legends attached to it, it has in the past been frequently cited by poets.

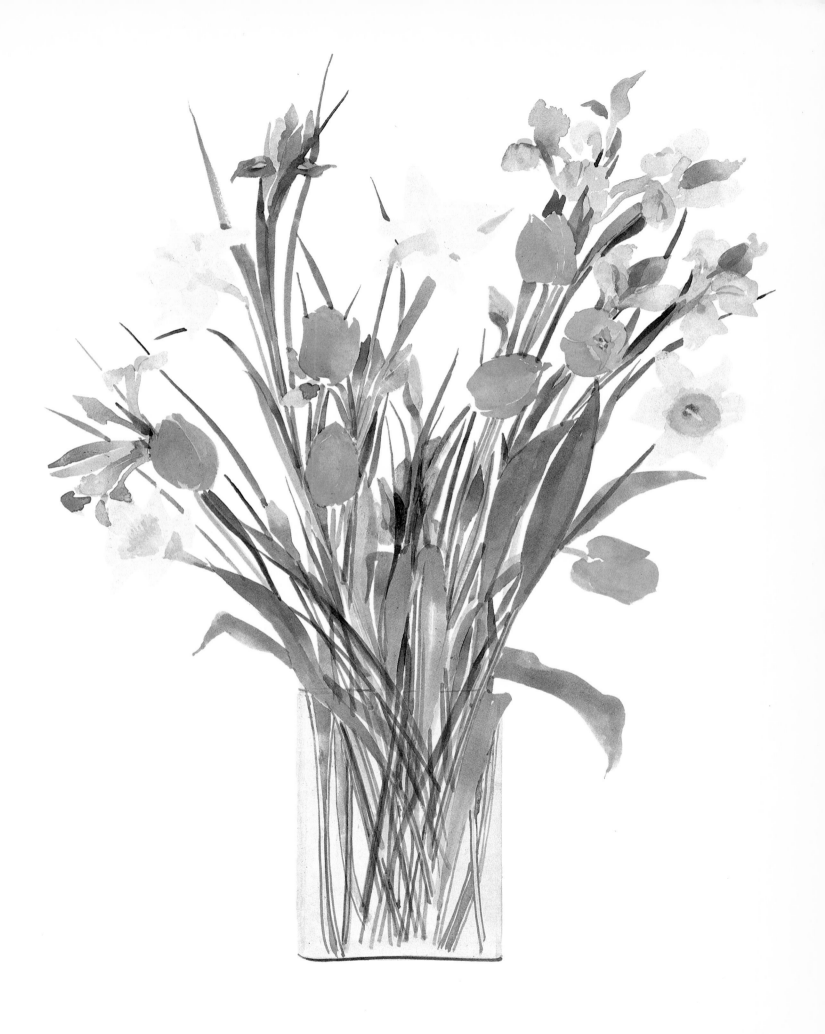

BRIGHT BOUQUET

Such a conglomeration of spring flowers intensifies the characteristics of each bloom. Once interspersed, the colours and shapes become more brilliant than when seen singly and the fresh green of leaves and stems threading through provides a perfect complement — the whole emanating light and nascent freshness.

Flowering plants are broadly divided botanically into two kinds, those in which the seed germinates with two seed leaves, and those in which the seed produces only one seed leaf. These divisions are called, respectively, Dicotyledons and Monocotyledons. Dicotyledons are represented in this collection by the bright and showy *Anemone coronaria*, whose brilliant blossoms contrast with the delicate colouring of the Monocotyledon *Freesia*. Two members of the genus *Narcissus*, also Monocotyledons, represent different species of that genus, the large and flamboyant trumpet hybrids of *Narcissus pseudo-narcissus* and the more delicate *N. poeticus*. The Darwin tulips are also Monocotyledons.

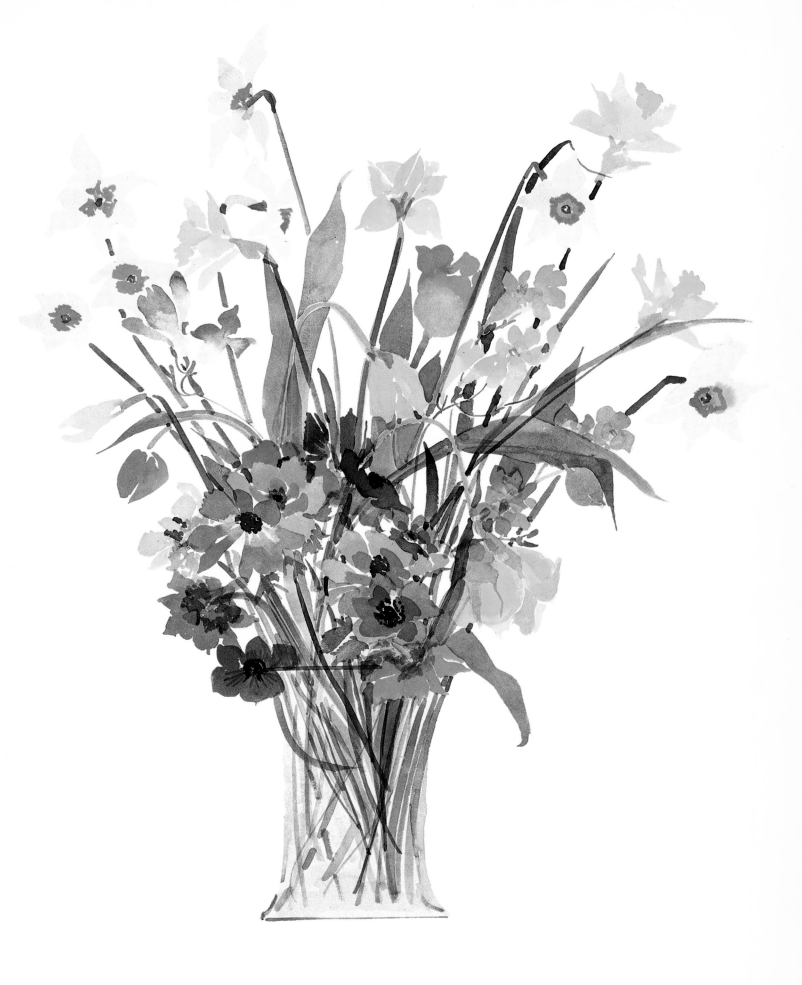

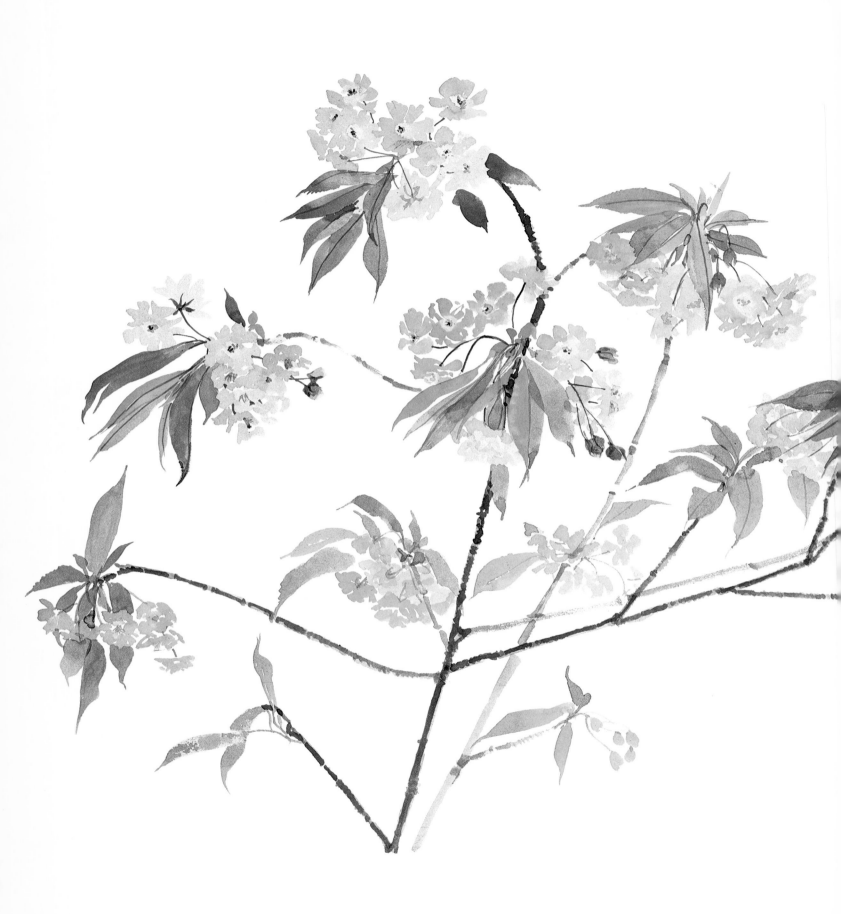

PRUNUS – PINK FINALE

Prunus provides the archetypal ornamental trees — classical in form with trunks branching out at shoulder height in arboreal arabesques. The apotheosis of the decorative tree, its blossoms appear before the leaves. The elegant line of the branches still remains visible as the profusion of flowers burst into blossom along them. The young leaves hardly intrude when they first appear, but gradually become more prevalent until that moment when the flowers are gone and the tree stands fully leafed.

From very early times the Japanese have cultivated hybrids and varieties of ornamental cherries and the cherry tree in bloom is inseparable from any Western image of Japan. These beautiful trees are thought to have been bred mainly from *Prunus serrulata* but other species were doubtless involved. As Japan was closed to the West until Victorian times they were not introduced here until the early twentieth century. Flowering after the almond and immensely floriferous, they have since been extensively planted, greatly brightening English spring gardens.

OPENING REDS

*Even without a calendar the tulip would mark the season, it blooms
precisely when spring is absolute. There's excitement as the first peep of
colour shows on the burgeoning spearhead, developing quickly to give a
classic tulip silhouette. When the flowers open, the firm petals appear to
do so jerkily as if by numbers to form the inverted umbrella-like bowl.
At this stage the intricate centre is revealed with a scent sweet and
astringent becoming strong. In fading, the flower contorts, twisting to
strike frozen attitudes as if in some strange dance. Then the petals will
drop like the discarded wings of an insect, the stamens follow and
finally the isolated pistil alone remains.*

The genus *Tulipa* consists of Monocotyledonous bulbous plants cultivated in western European gardens
since the sixteenth century. Many of the species are native to the steppes of eastern Europe and western
Asia, growing in the wild in heavy compact clayey soil that dries out completely in summer, becoming
arid and hard. After Russia conquered central Asia in the nineteenth century, a number of hitherto
unknown species were discovered and brought to the West. Among them, introduced in 1904, was one
which possessed a reddish-brown bulb somewhat larger than most of the other species. Named *Tulipa
fosteriana* Hoog, it turned out to be one of the most spectacular of the early flowering species, with huge
flowers as much as nine inches across when open.

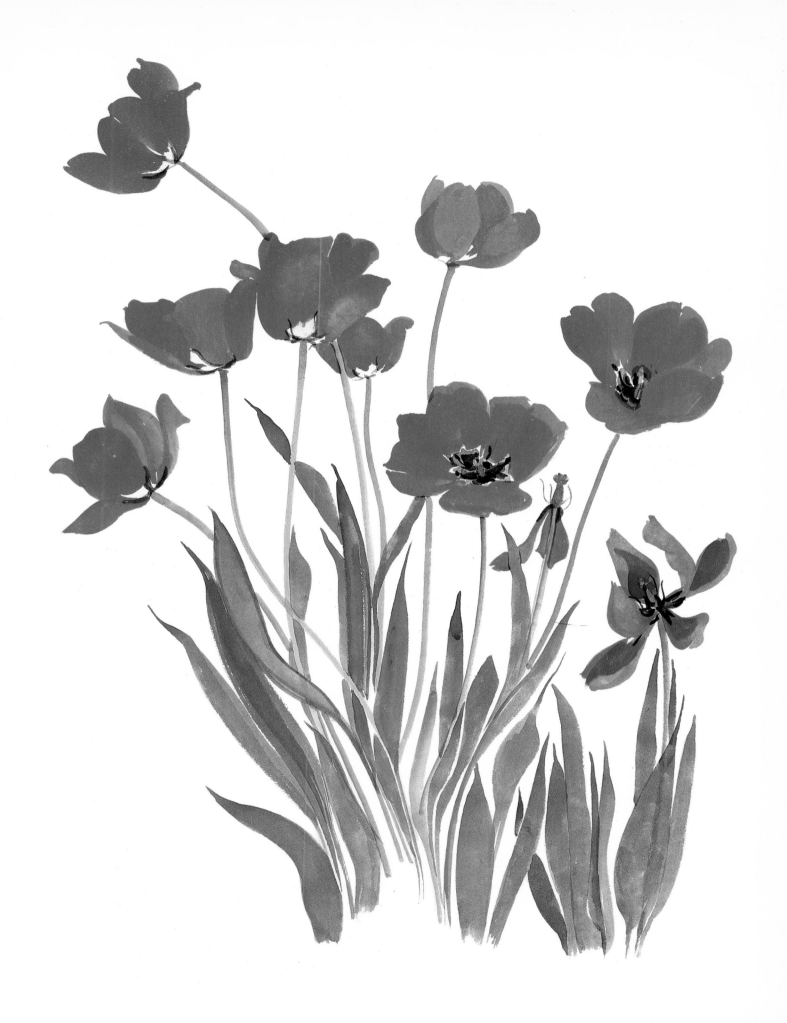

EASTER DAY

There was a moment when the polyanthuses were nearly over and the freesias only just beginning. Painted together on Easter Day, they had a transitional feeling that seemed to symbolize the spirit of the Christian festival.

Ivy is a member of the genus *Hedera* of the family *Araliaceae*. This is a small genus, consisting of a few species only, including the one most familiar in Britain, *Hedera helix*, the Common Ivy. *Hedera* is the old Latin name for ivy used by Virgil and Pliny: *helix* means 'spiral' or 'twisted', a reference to its habit of growth. The plant produces first creeping or climbing shoots with aerial roots and the familiar lobed leaves, but when it reaches the top of its support the branches become bushy, dispense with aerial roots and produce unlobed leaves. The plant flowers in October only on these bushy branches, bearing dull, inky-black, sinister-looking berries.

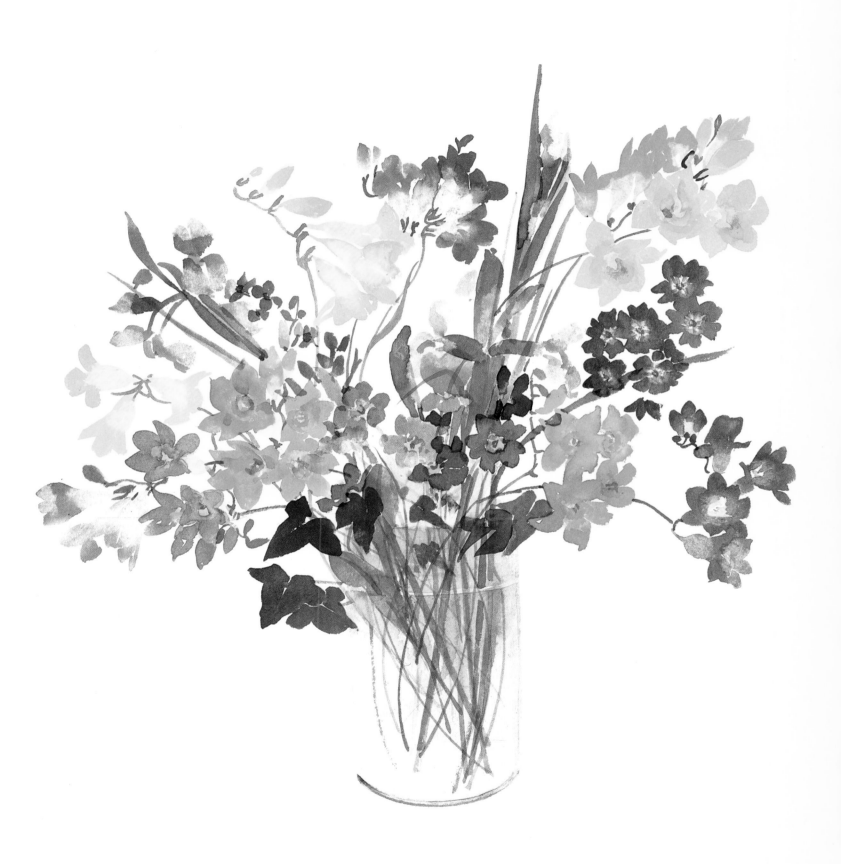

PANSIES STARTLED

Pansies and violets are kin. Both have a secrecy of behaviour endorsing the poet's image of the shy violet. Initially their leafage is dominant and the flowers are scarcely noticeable, but slowly increase to become paramount. The flowers bow their heads at first, inclined down perhaps to shelter their seeds from rain or dew. Later they face up, erect and quite surprised.

The brightly coloured giant pansies of today are the descendants of much more modest, but none the less attractive, ancestors. The name of the genus, *Viola*, is the old Latin name of the violet used by Virgil, violets also being included in this genus, which belongs to the family *Violaceae*. Development of the modern pansy first began in private gardens in the early part of the nineteenth century with the collection of good forms of the Heartsease: Lord Gamba's gardener, named Thomson, who cultivated one such collection for his master, branched out on his own as a nurseryman with such success that he became known as 'Father of the Heartsease'. In the 1850s many other breeders took up the plant, with the results we know.

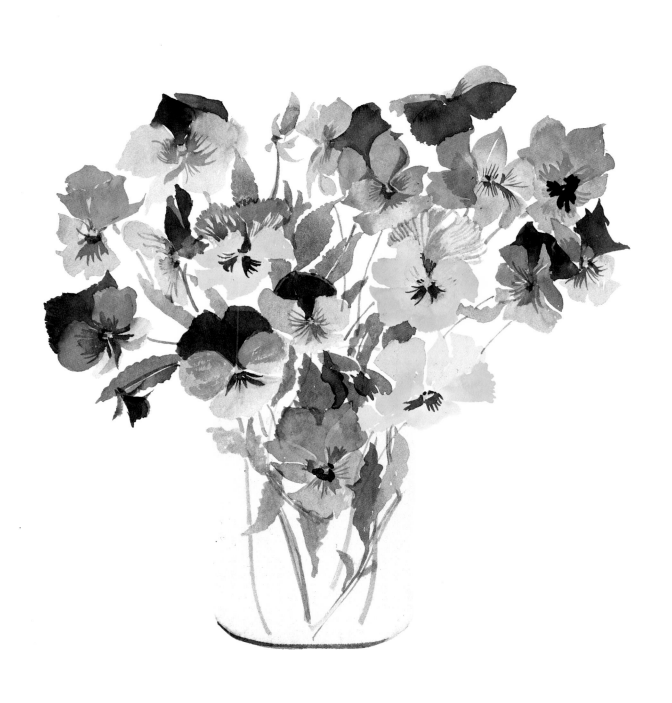

BEARDED IRIS AND CLEMATIS ENTWINE

The darkest of the purple irises, in flower earlier than customary, didn't seem to be disconcerted by the intrusion of the Lasurstern Clematis. The clematis grew surreptitiously, remaining unnoticed until it flowered, with its enormous heads of petals, cartwheeling askew across the border. Accidentally this made a most fortuitous combination of strongly contrasting textures, in shades of delicate mauve and deep velvet purple, giving an air of tranquillity.

The genus *Clematis* is a member of the family *Ranunculaceae* and contains several hundred species of climbing and herbaceous plants. From some of these numerous garden hybrids and varieties have been developed, characterized by the large size of their flowers. These include 'Lasurstern', whose flowers, six to seven inches wide, open perfectly flat. The generic name *Clematis* is derived from the Greek *klema*, 'a vine branch', alluding to the vine-like habit of the climbing species.

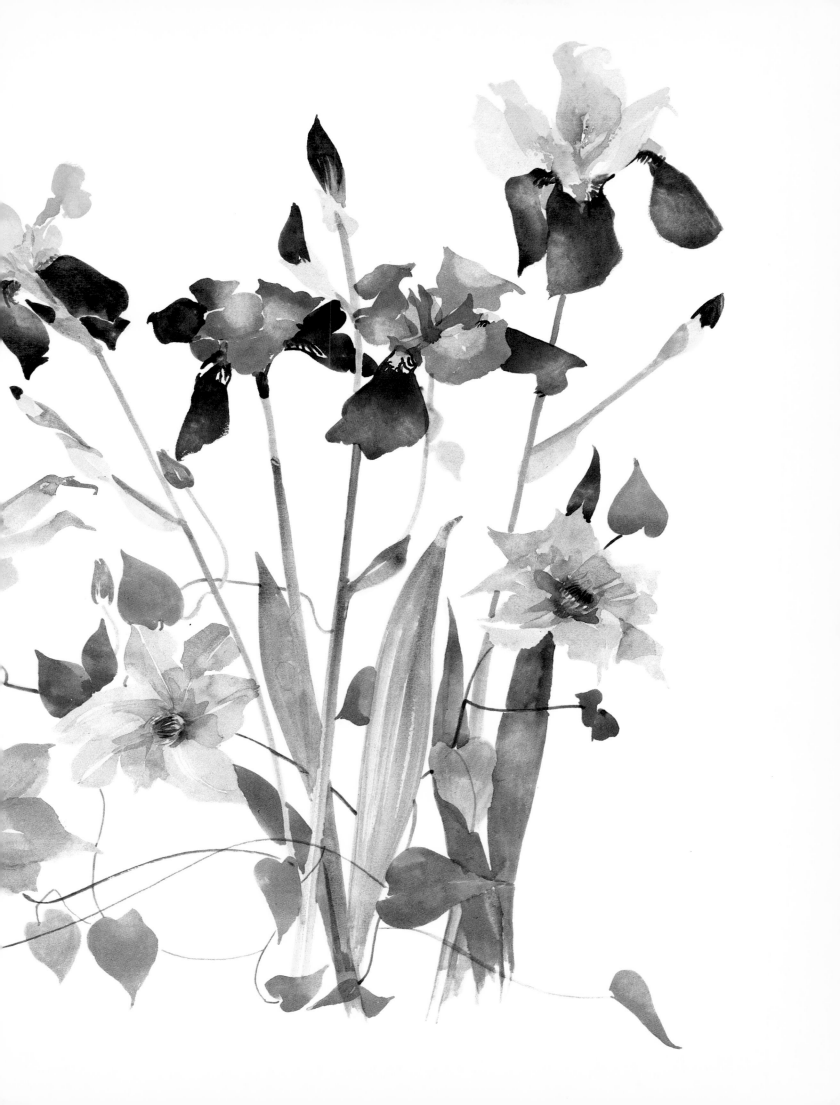

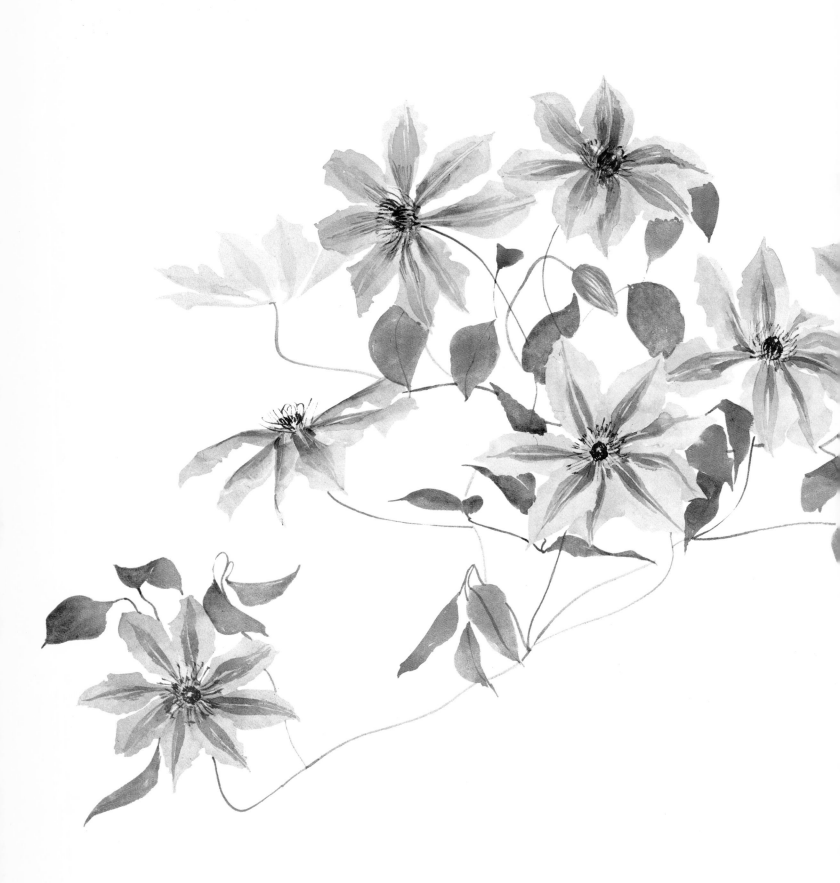

NELLIE MOSER'S
ANNUAL FROLIC

Clematis have a universal appeal, particularly the larger flowering kinds. Of a most amiable disposition they accept restraint and can be cultivated in the smallest areas, and even tolerate being submerged by their neighbours after flowering. Their robust habit is to climb by wiry leaf stalks and produce big flowers on slender stems. Nellie Moser is the most spectacular. Its freely flowering elegantly striped petals creating an illusion of movement — spinning as if manipulated by some accomplished juggler.

Two species of *Clematis* which have been hybridized with great success to produce a number of spectacular very large-flowered crosses are *C. florida* and *C. patens.* The former is a native of China, introduced into Britain in 1776 and the latter, which came to the West sixty years later, of Japan. The epithet *florida* means 'rich in flowers' and *patens* means 'spreading'. The variety 'Nellie Moser' is one of the most popular and widely planted of the 'Patens and Florida group' of *Clematis*, as it is now called.

EARLY MAY

Heavy spring rains are a frequent prelude to May. The vegetation, drenched and freshly nourished appears to double in size overnight. Lush, moist, warm conditions bring out the bluebells and lilies-of-the-valley in an upsurge of flowering spikes. The flowers of both plants are singularly chaste. Bell-shaped they modestly bow their heads perfuming the air with the sweetest of scents.

Botanists have differed over the name of the genus to which the bluebell belongs, the changes being rung between *Hyacinthus*, *Scilla* and *Endymion*, but all are agreed on the epithet *non-scriptus* and that the plant belongs to the family *Liliaceae*. The epithet *non-scriptus*, 'not written upon', refers to the 'doctrine of signatures' which declared that each plant had characteristics by which its proper use could be deduced, presumably absent in this case. The lily-of-the-valley, *Convallaria majalis*, is an ancient garden favourite. The generic name *Convallaria* is from the Latin *convallium*, a valley, referring to the normal habitat of the plant, and *majalis*, the month of May, its time of flowering. The fruit of the Meadow Cranesbill, *Geranium pratense*, resembles the head and beak of a crane, hence its name, derived from the Greek *geranos*, a crane.

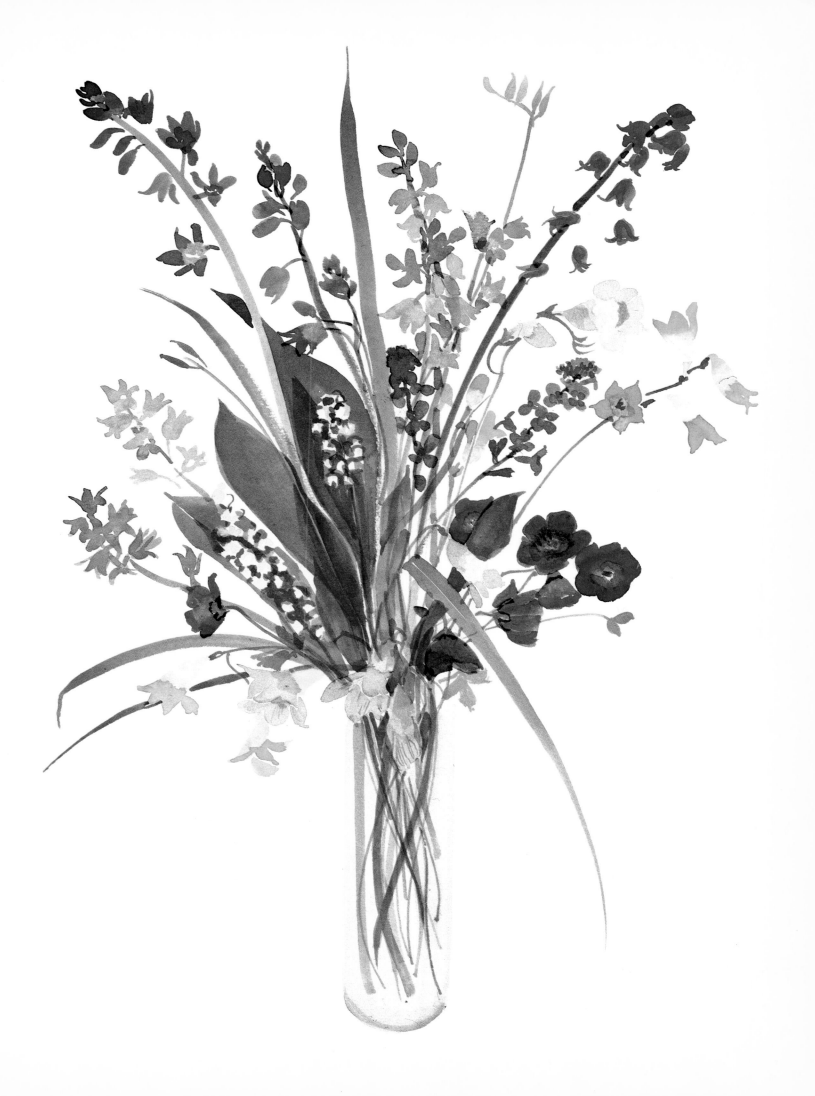

IRISES
DRAMA FOR MAY

The iris is the archetypal symbol of the sceptre and therefore makes a truly royal contribution to our gardens. In flower it is sumptuous with petals velvety or diaphanous. The colour has a unique quality: shades range from trenchant imperial, plummy or indigo purples, to pastels so pallid the colour eludes identity. When grouped together in full flower, I see the dark variety stalking the garden like samurai, the pale ones adjacent as the courtly Japanese women to whom they pay homage.

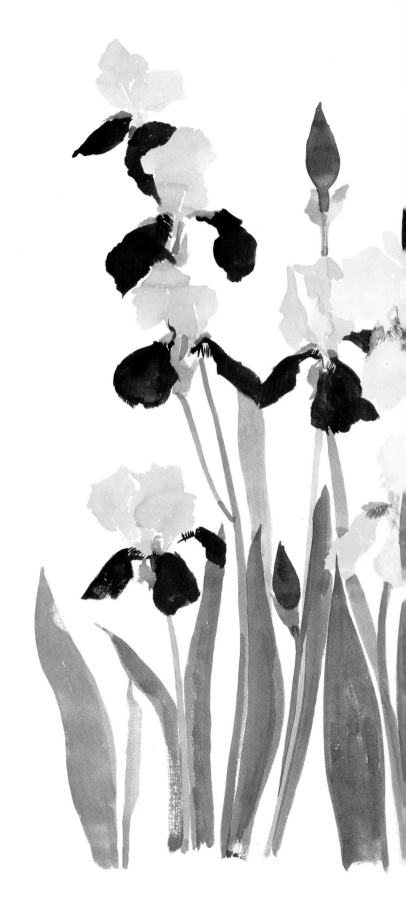

Iris germanica L. (syn. *Iris barbata*), the 'Bearded Iris', is a native of southern Europe, now found naturalized, often in a hybrid form, over wide areas elsewhere. The fleshy rhizome from which it grows is not difficult to propagate and the plant hybridizes easily so that there are a large number of garden varieties in cultivation. The petals of the flower, which is fragrant, are of two kinds, having different habits of growth: the 'standards' stand upright and the 'falls' hang down. At the base of each 'fall' is a kind of fuzz resembling a beard, from which the plant takes its vernacular name.

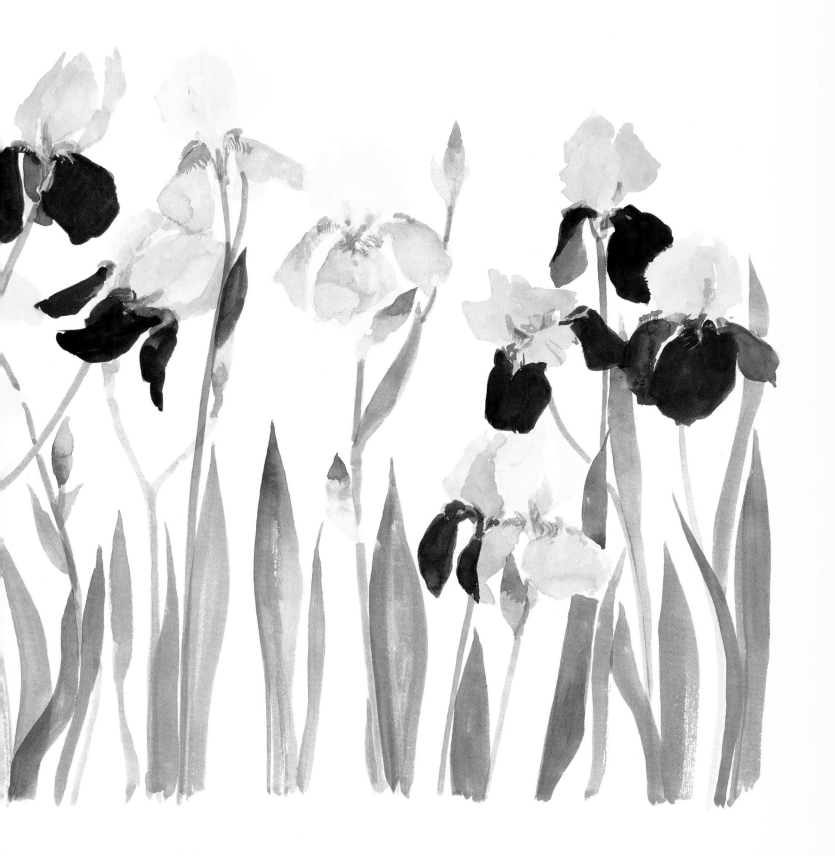

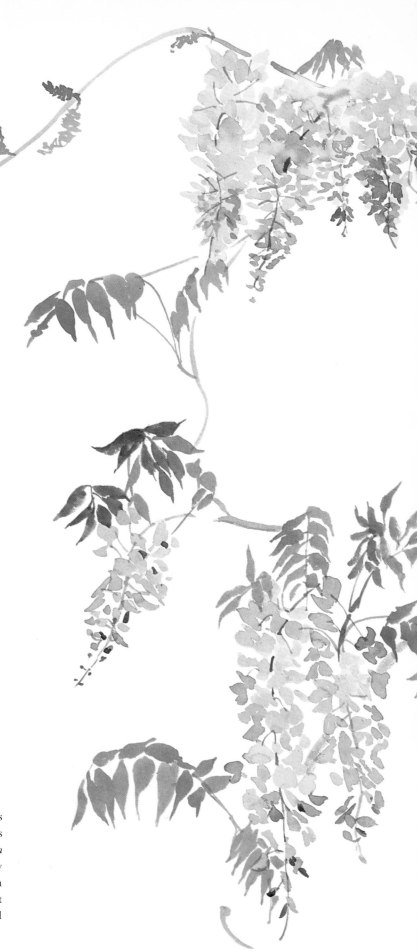

WISTERIA IN BREEZE

Wisteria always carries an air of mystery whether blossoming in its customary pale lavender or rarer white. The long racemes of threaded flowers hang down in fringed tiers to create a fairy tale curtain. Rippling in the breeze on a wall or trellis there's additional magic in its elusive almond scent.

Wisteria is so closely connected with the English country scene that it is surprising to find that *Wisteria sinensis*, the species most usually planted, was not introduced into Britain from China until 1816. The genus *Wisteria* contains only six species, all climbing plants. It belongs to the family *Leguminosae*, which includes the peas and beans. It needs to be planted with care and its growth watched as it is a vigorous wilful plant and not infrequently damages sewers or parts of buildings, breaking even metal pipes and supports.

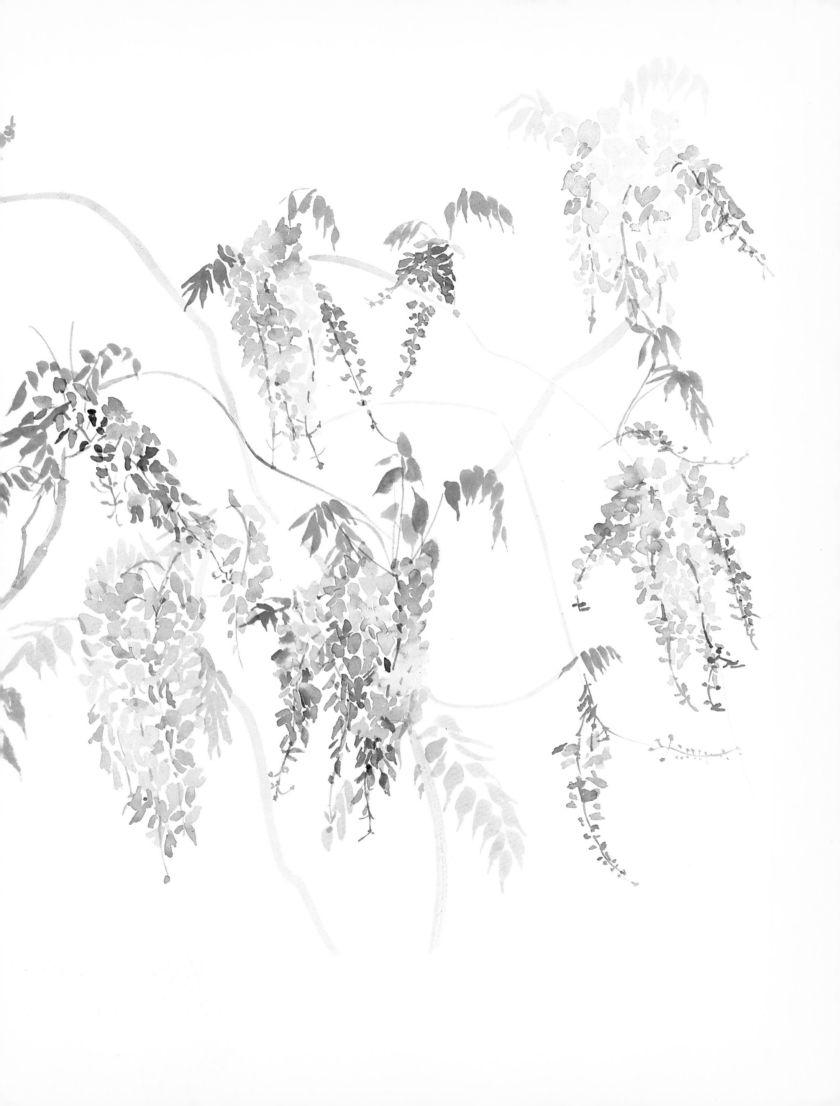

LABURNUM – GOLDEN RAIN

The solitary laburnum seen in a suburban setting has really come down in the world, far removed from its origins among Europe's higher mountains. In cultivation, its reputation has also suffered from the poisonous nature of its pods. Properly placed and sensibly treated, however, laburnums can be a beautiful asset to the garden: most shapely and decorative in the way they flower and leaf. Their racemes of pale yellow, pea-like flowers give a fantastic impression of a tree dripping with golden wisteria — a treasure stolen from the garden of Midas.

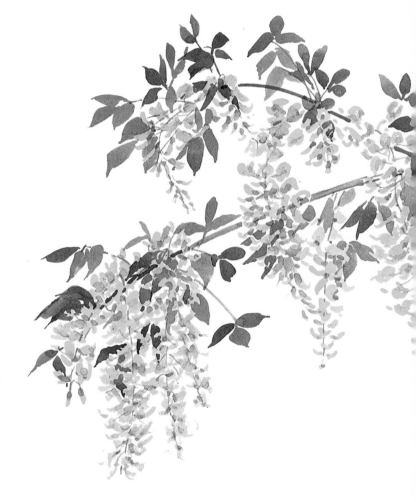

The genus *Laburnum*, of the family *Leguminosae*, consists of three species only, two of which, *L. anagyroides*, the Common Laburnum, and *L. alpinum*, the Scotch Laburnum, are small trees while the third hardly achieves that status. There is also a remarkable 'hybrid' called *L. adami* which is a botanical curiosity. It was not obtained by pollination and seeding between two species of the same genus as is usual, but by the grafting of a species of a different genus, *Cytisus purpureus*, the Dwarf Purple Broom, on *Laburnum*.

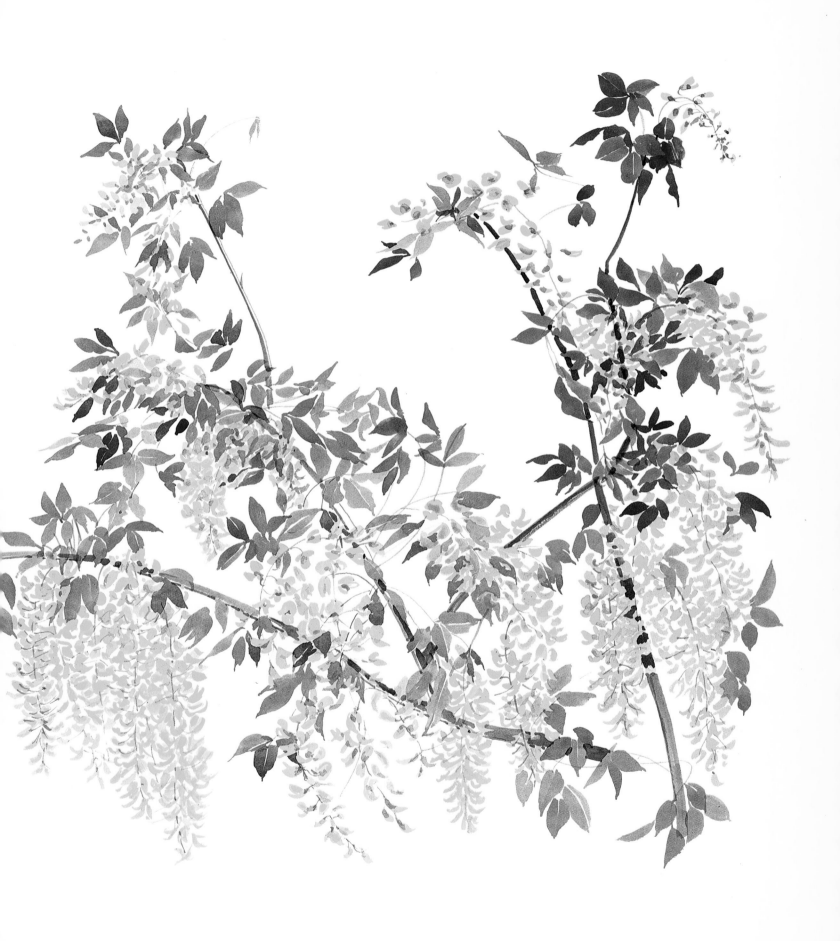

SIGNALS FOR SUMMER

Combining the first Oriental Poppies with Siberian Irises and foxgloves seemed especially significant — a bridge linking late spring and early summer. Even the accidental relationship of leaves and stalks was a happy one, forming a pattern that perfectly balanced the flowers above.

Poppies have been cultivated back to remote antiquity and the origin of the name of the genus, *Papaver*, is not certain. The epithet *orientale* means 'eastern', and to Western peoples this seems appropriate as *Papaver orientale*, a native of the Mediterranean regions, is also found in Armenia, the southern Caucasus and Iran. Poppies, of which there are a large number of species, belong to the family *Papaveraceae*. All parts of the plant of *P. orientale* are densely covered with silky hairs and it has brick-red flowers six inches or more in diameter carried on long generally leafless stems. There are many delightful cultivated varieties with flowers larger even than this.

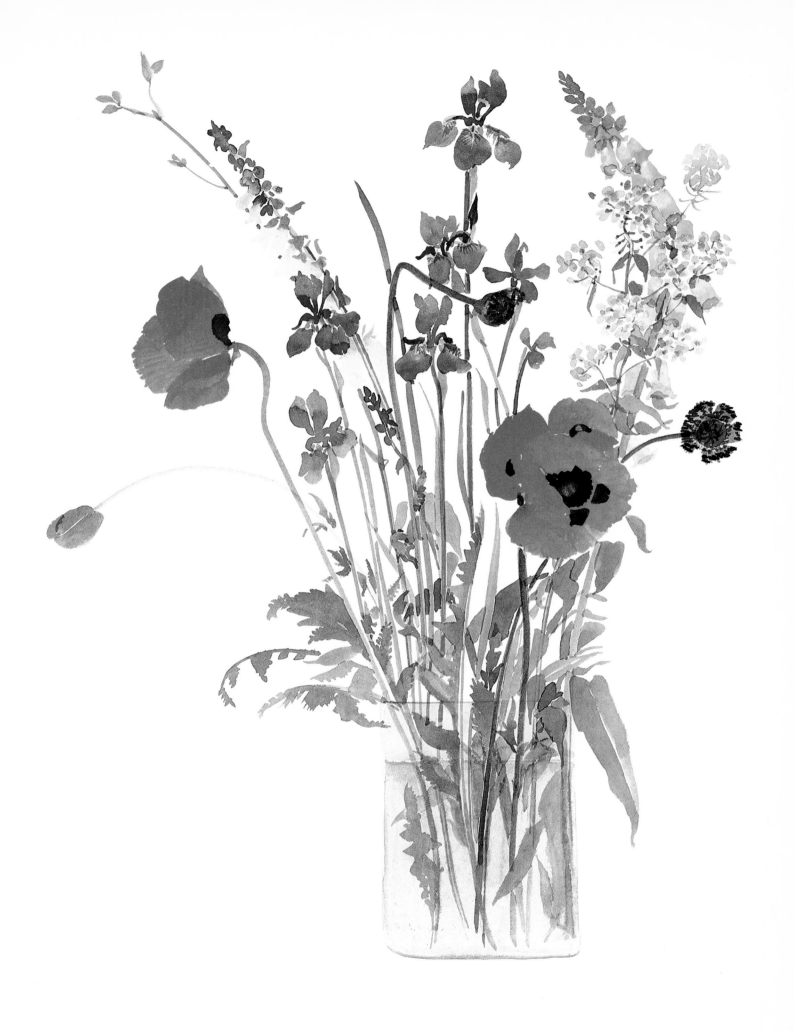

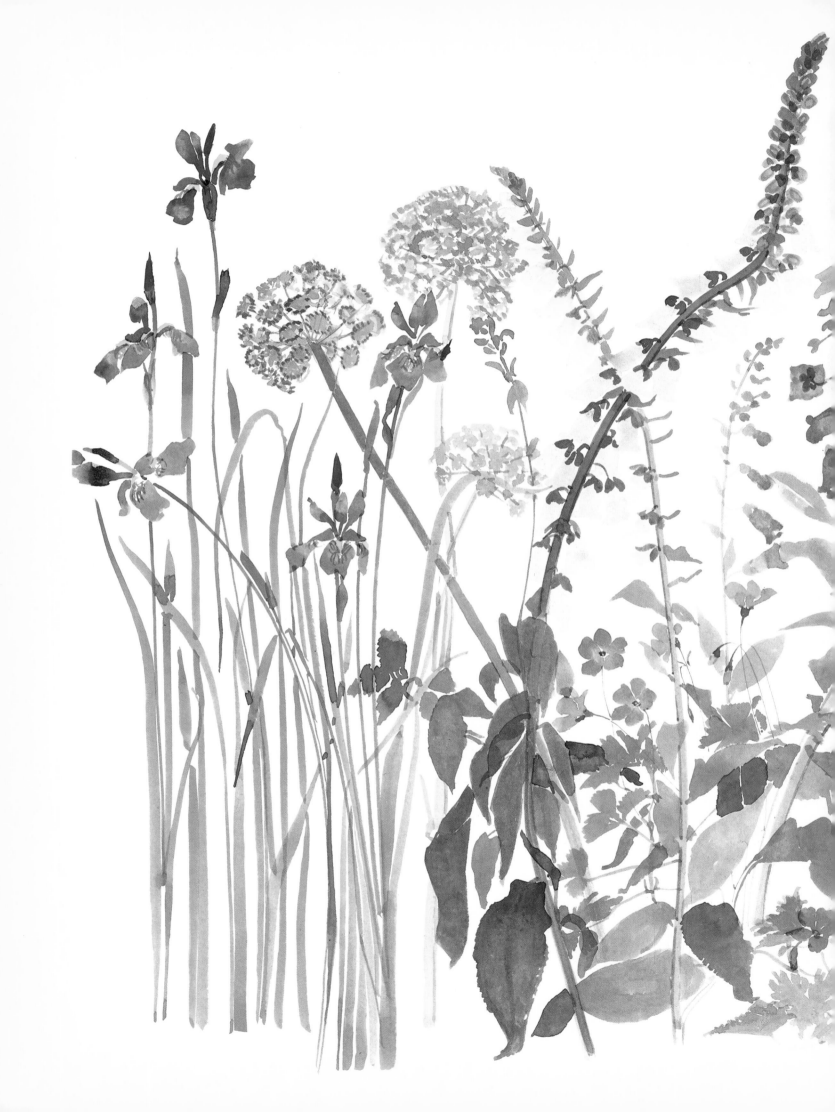

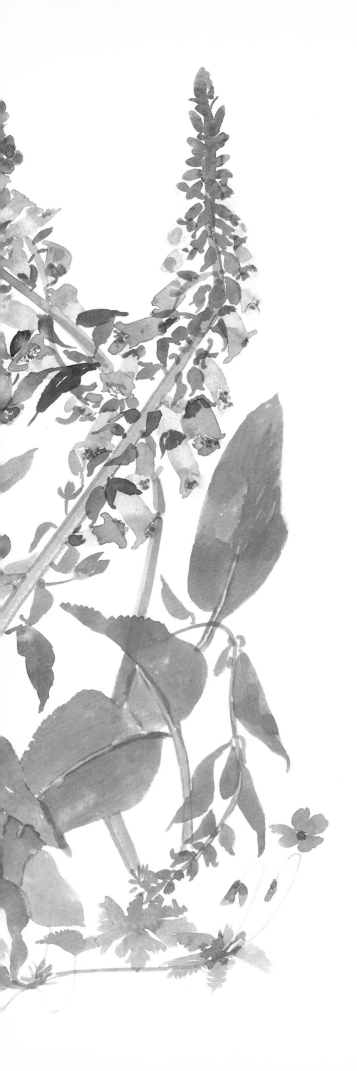

EARLY SUMMER IN THE WILD GARDEN

Foxgloves are appropriately prominent here, being an essential ingredient in any wild garden. They are singularly agreeable plants with a nature to match their strange beauty. Good neighbours, they do not deplete the soil they grow in but actually add sustenance, thus helping others to increase growth and resistance. Even when cut they behave benevolently, prolonging the lifespan of their companions in a vase. The Siberian Iris flourishing alongside, while not the most spectacular product of its family, makes a welcome contribution, its blue flowers aglitter against the dark foliage.

The foxglove, *Digitalis purpurea*, belongs to the family *Scrophulariaceae*. The epithet *purpurea* means 'purple', the usual colour of the flowers. *Iris sibirica*, the 'Siberian Iris', is a native of central Europe and Russia and has many forms which vary in colour. There are two species of the genus *Angelica*, which belongs to the family *Umbelliferae*, *A. sylvestris*, the wild angelica of the woodlands, and *A. archangelica*, which is larger, with green stems and a strong smell.

DIGITALIS PINK

Digitalis is a surprisingly sophisticated name for such a familiar countryside plant. The eminent Dr Fuchs (of fuchsia fame) coined it from the Irish description of the flowers as 'Deadman's Thimbles' — a macabre connotation for these attractive, tubular bell-shaped flowers growing in tall spikes. The uppermost flowers are tight-lipped, those below slowly opening out more fully as they graduate down the stem. An ingenuous flower, it is perfectly suited to its usual habitat in hedgerows and woodlands, and indispensable for a wild garden.

There is an interesting botanical story attached to *Digitalis purpurea*. In the latter half of the eighteenth century Dr William Withering attended a lady who had oedema (accumulation of fluid), associated with a failing heart, and who, he thought, had not long to live. She improved greatly after taking a herbal mixture provided by a neighbour. This aroused his curiosity and, obtaining a list of the ingredients, he ascertained that foxglove was probably the active principle. Later investigation discovered that the foxglove plant contained *digitalin*, used even now in the treatment of the failing heart, no synthetic drug having yet been found which is as effective.

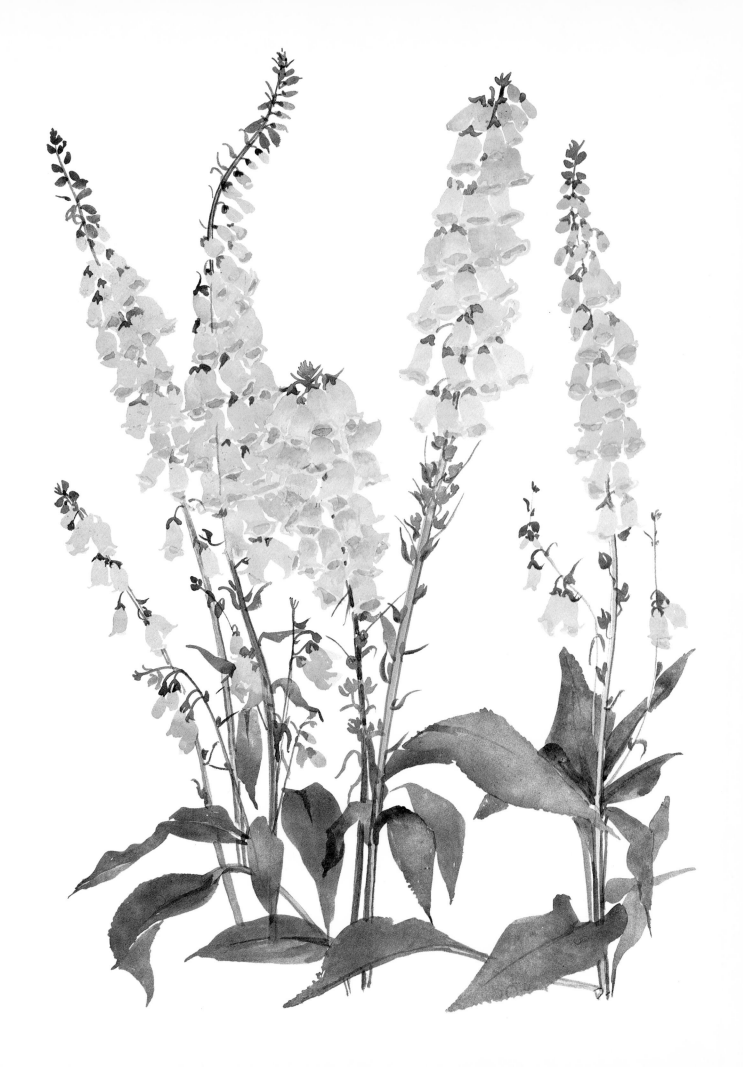

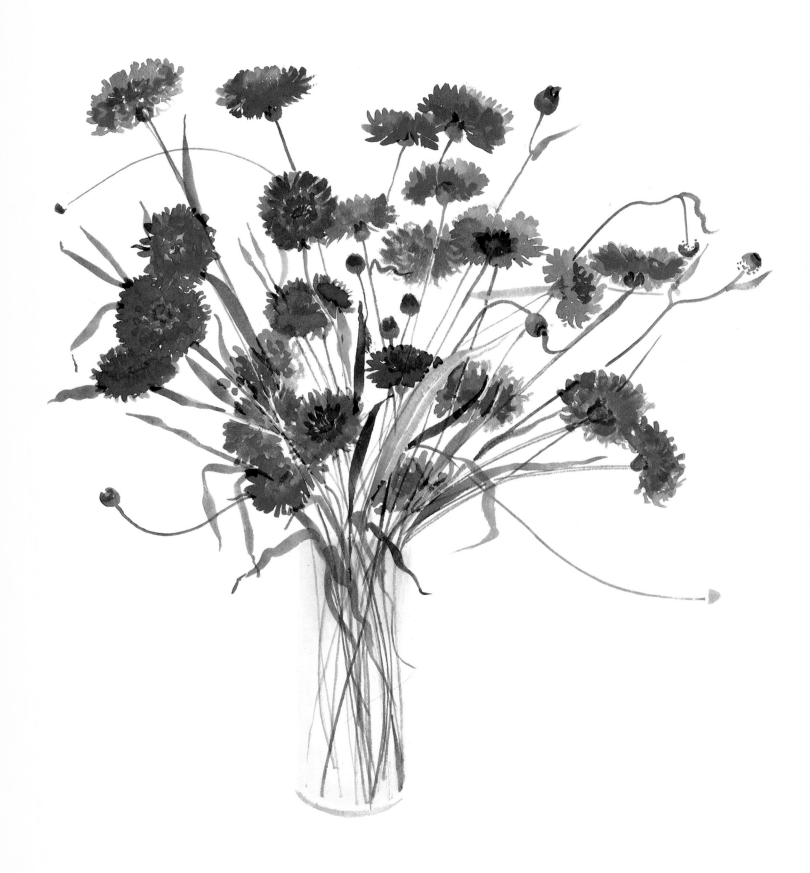

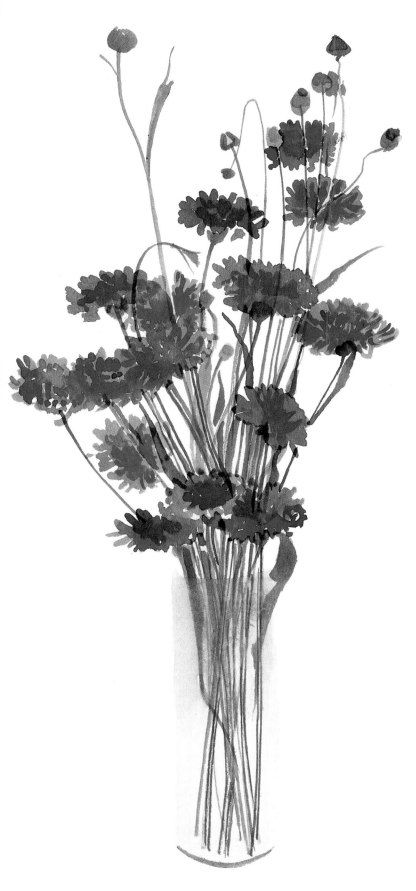

CORNFLOWERS
TWICE

In common usage 'Cornflower Blue' is definitive. Yet even so, the flowers seen again are so much bluer than remembered. Their blue is really blue, absolute, a primary colour. The cornflower lacks an identifiable scent but is still frequently used in pot pourri. Those blue glints looking like flakes of lapis lazuli are its petals.

The intense blue of *Centaurea cyanus* L. (syn. *Centaurea arvensis*) was a common sight in European wheatfields before the days of selective weedkillers, hence the vernacular name of 'Cornflower'. A compact, bushy, erect plant with small, narrow pointed leaves, growing about two feet high, it has been taken up and developed by breeders, who have reared white and pink forms and bred a number of hybrids as well as a dwarf strain. The flowers of the original species have been known and admired since the time of the ancient Greeks, both the generic name *Centaurea* and the specific epithet *cyanus* being derived from Greek legend.

COLOURS SWEETLY CLASHING

Early summer has a special palette. The colours are primarily pastel, but never wishy-washy. Here are the year's clearest shades of pink and mauve — intense, but never strident. The purity of these fresh positive colours means they complement each other marvellously, even flowers ostensibly discordant, happily combine, adding an extra sparkle to the season's joie de vivre.

The genus *Phlox* of the family *Polemoniaceae* comprises about fifty species all native to the northern temperate zone of America except one that occurs in Siberia. The generic name *Phlox* is derived from the Greek word *phlox*, 'flame', an allusion to the brightness of the flowers. The modern plants grown in gardens are hybrids between *P. paniculata* and *P. maculata*. The heads of flowers, called botanically 'panicles', hence the epithet *paniculata*, are as much as a foot long in these hybrids and of a wide range of brilliant colours, often with a central eye of contrasting colour. The genus *Hydrangea* belongs to the family *Saxifragaceae*. The generic name is derived from the Greek *hydor*, 'water', and *aggeion*, 'a vessel', a reference to the shape of the seed capsule.

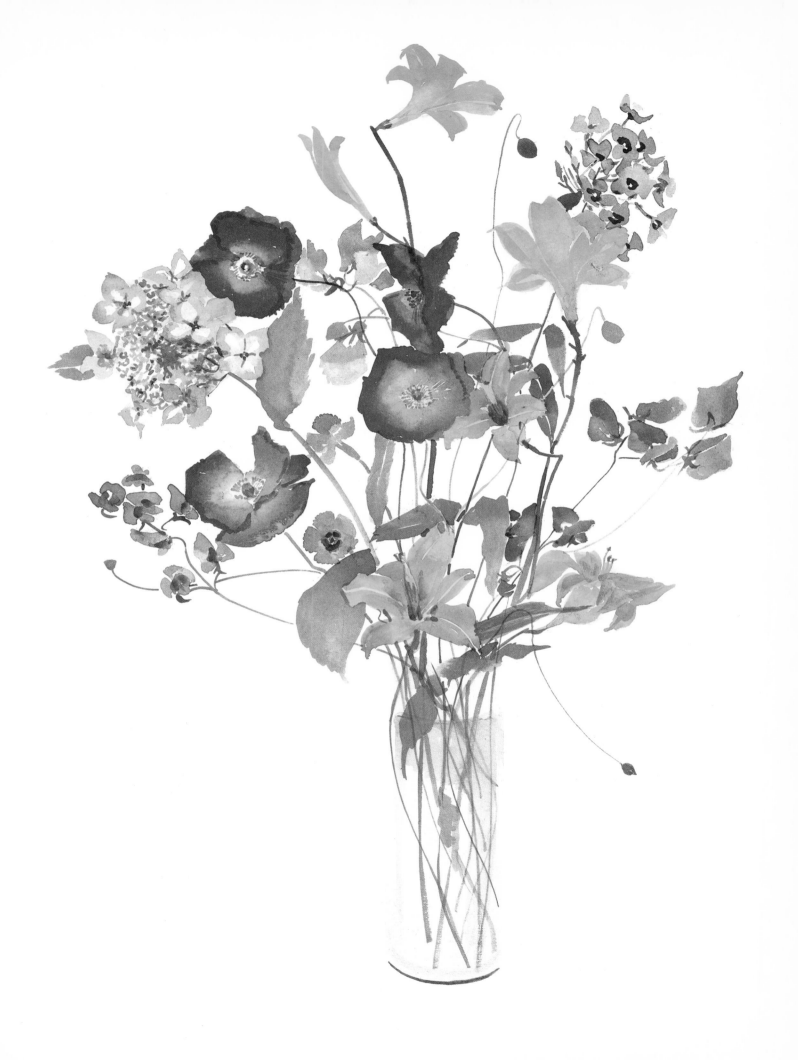

POPPIES – ZENITH

The Oriental Poppy is the most flamboyant poppy of all, flowering in striking vermilion shading to purest cadmium red. Literally bursting from bud into flower, it blazes with an intensity unsurpassed elsewhere in the garden. The crinkly petals combine surfaces both matt and satiny with marvellous centres, stunning creations of emerald greens and sapphire blues, set off by a ruff of jet black stamens — an inspiration for a mogul's jeweller.

So vigorous is *Papaver orientale*, the Oriental Poppy, that this plant can in favourable circumstances become almost rampant. Like most poppies it prefers a dryish sandy soil in full sun, making roots as thick as one's thumb, penetrating down to the damper layers below. Again, like other poppies, its flowers, though superb when freshly opened, are very fleeting. It is one of the showiest of hardy perennials and is very long-lived, doing best when undisturbed, and is particularly at home in calcareous soils.

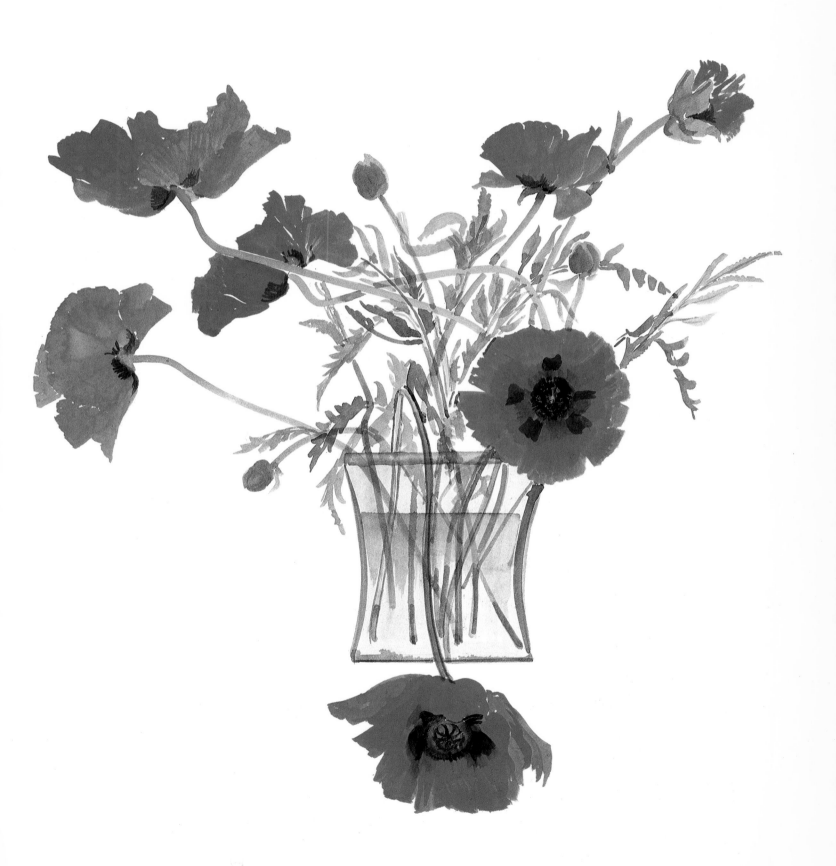

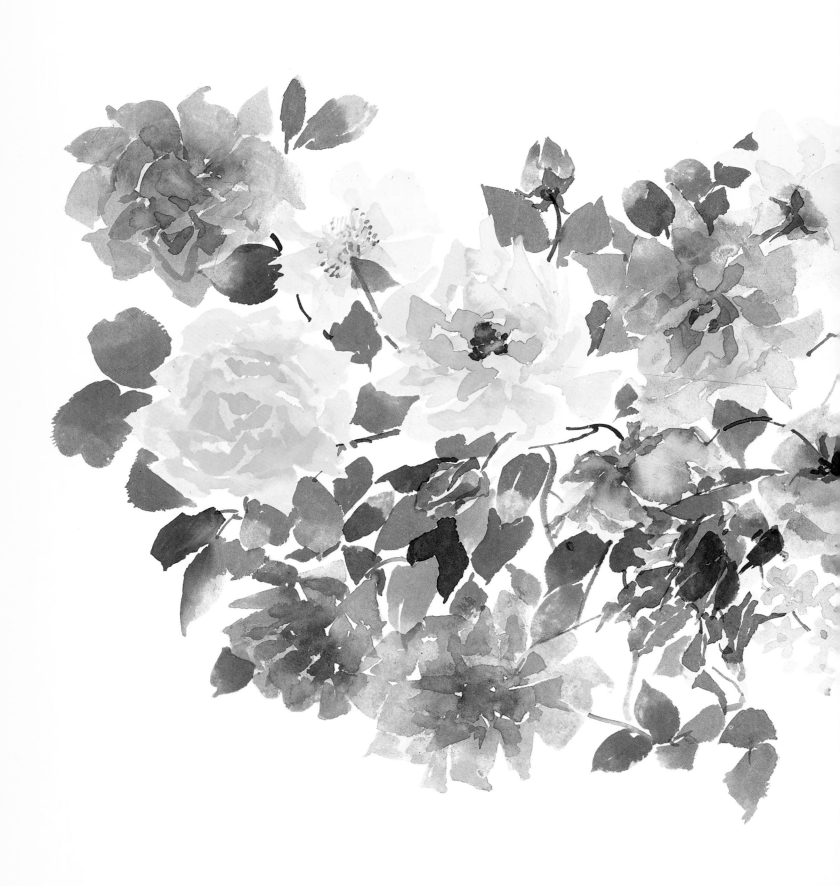

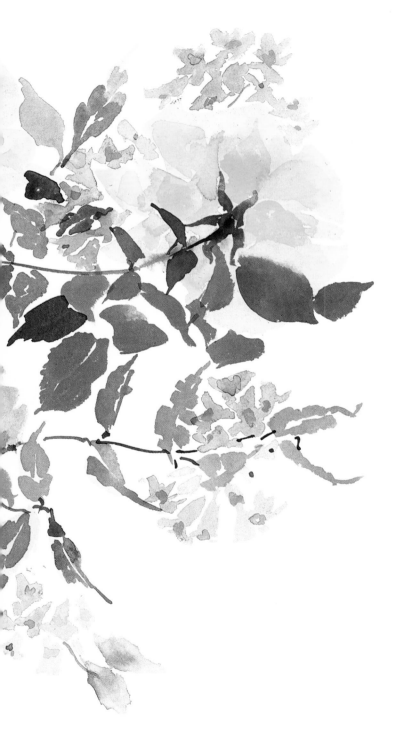

ROSES WITH WEIGELA

When the old roses bloom, their opulence makes the spring flowers seem austere by comparison. These roses are profuse and showy. Diversely coloured, they ravish the eye and sate the nose with scent, in the year's first orgy. Although many kinds have short flowering periods and some may only bloom once, they are the indisputable hallmark of summer.

The *Weigela* (often still called *Diervilla*) of our gardens are hybrids, bred mainly from *W. florida* (syn. *Diervilla rosea*), native of northern China and Korea, and *W. coraeensis* and *W. floribunda*, which are both natives of Japan. These highly floriferous and decorative shrubs are comparative newcomers to the West, the first, *W. florida*, not being brought to Britain until 1845. The genus was named after C. F. Weigel, a German professor of botany, and is part of the family *Caprifoliaceae*. There are several hundred hybrids and varieties, all easy of cultivation.

EVERLASTING PEA

The Everlasting Pea is a coarse relation of the cultivated annual varieties. More rugged in character it recurs each year, climbing vigorously without staking to cover bare walls, fences or rocks. Flowering from whippy stems, most commonly in a bright cyclamen colour, the central keel-shaped petals haloed with plummy purple. The flowers fade interestingly, becoming bluer — some even developing surprising turquoise tints.

Lathyrus grandiflorus, the Everlasting Pea, a hardy herbaceous climbing perennial growing about six feet tall, is a member of a genus which has representatives in most temperate parts of the world. Its generic name *Lathyrus* is the Greek name for pea used by Theophrastus, the Greek scholar who was the first to record plants systematically. The epithet *grandiflorus* means 'large-flowered'. The genus is placed in the family *Leguminosae*. *L. grandiflorus*, which is itself native to southern Europe, is a long-lived plant, from which quality it derives its common name of 'Everlasting Pea', by contrast with its short-lived annual relatives like the Sweet Pea.

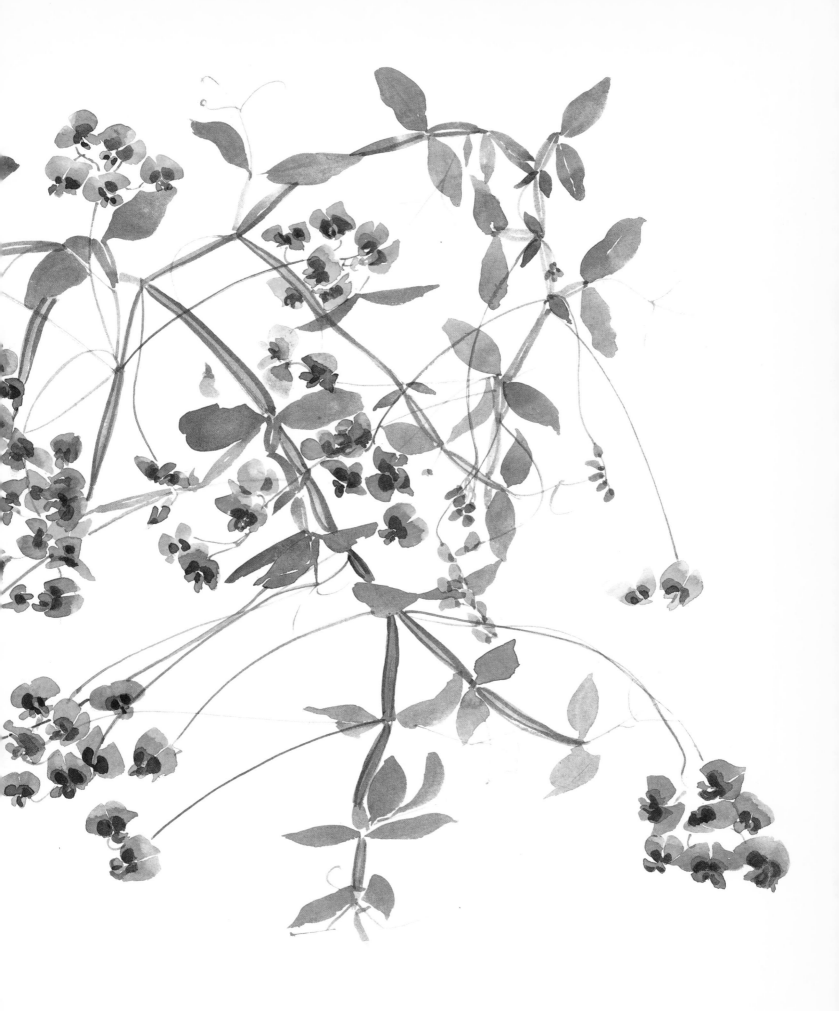

ROSA MUNDI WITH SWEET PEAS

Surprisingly, there's still a War of the Roses — militant, but fortunately not as bloody as the original feud between Lancaster and York. It seems not everybody is enthusiastic about the traditional striped and variegated roses; many reject them with a disproportionate vehemence. It's sad indeed that any flower can incur such dislike. I find them totally capitvating.

The Tudor emblem, the Tudor Rose, is a combination of the York and Lancaster Roses. This rose has its counterpart in the garden, for one of the Summer Damask Roses (*R. damascena*), a rose with a white background blotched with pink, has for long been called the 'York and Lancaster Rose'. Very much like it, but distinguishable from it if both roses are seen together, is a sport of the ancient Provins Rose known as 'Rosa Mundi', a pale pink rose heavily blotched and striated with red. In older writers the name of this rose is given as 'Rosamonde', from 'Fair Rosamond', Henry II's mistress.

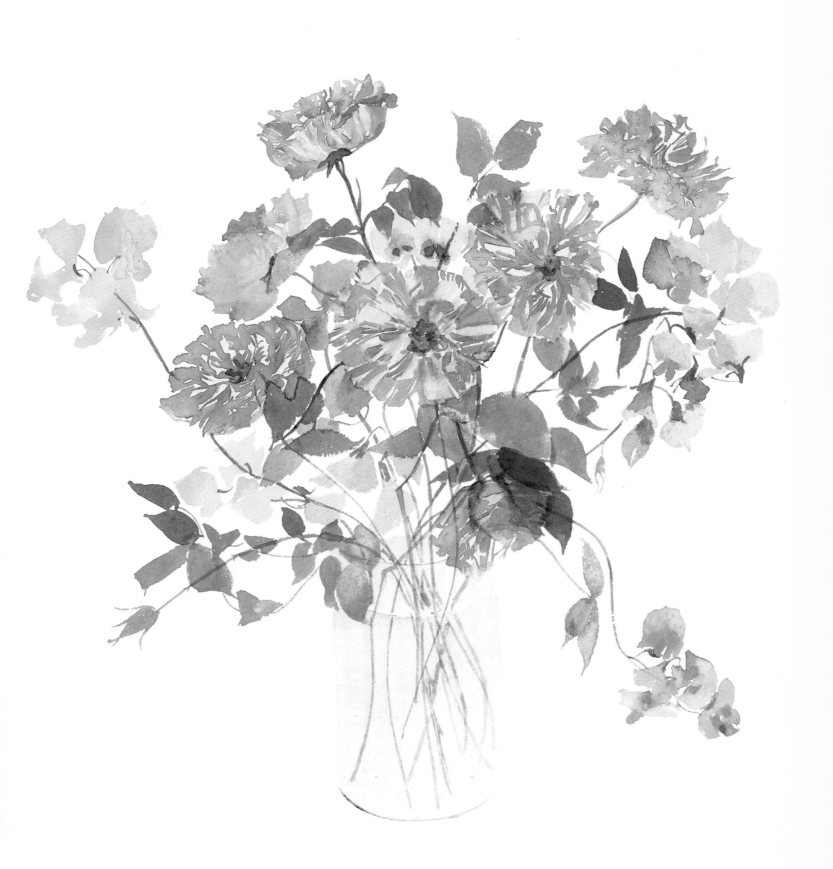

WILD GARDEN FANTASY

The less constrained growth in the wilder part of the garden provides green and shady pockets where any accidental colour sparkles in contrast. The Welsh Poppies here just happened — flowering with soft yellow cups nodding on wiry stems to define a path. Nearby, gigantic angelica, and foxgloves starkly white and green, seemed even more statuesque in comparison. The magnolia arching across the foreground adds a touch of fantasy.

Meconopsis cambrica, the yellow Welsh Poppy, is Britain's own native relative of the famous Himalayan Blue Poppy (*M. betonicifolia*) and itself an inhabitant of rocky woods and shady places. The generic name *Meconopsis* is derived from two Greek words, *mekon*, 'a poppy' and *opsis*, 'like', i.e. 'poppy-like': *cambrica* means 'of Wales', so the meaning of the whole is 'the poppy-like flower of Wales'. The genus is a member of the family *Papaveraceae*. Magnolias were named after Pierre Magnol, a professor at Montpellier University in France. The genus gives its name also to the family, *Magnoliaceae*, to which it belongs. There are two groups of *Magnolia*, one found in the eastern United States and another larger one in India, China and Japan. *M. watsonii* depicted here is thought to be a hybrid between two of the species of the Eastern group, but which species were the parents is not certain.

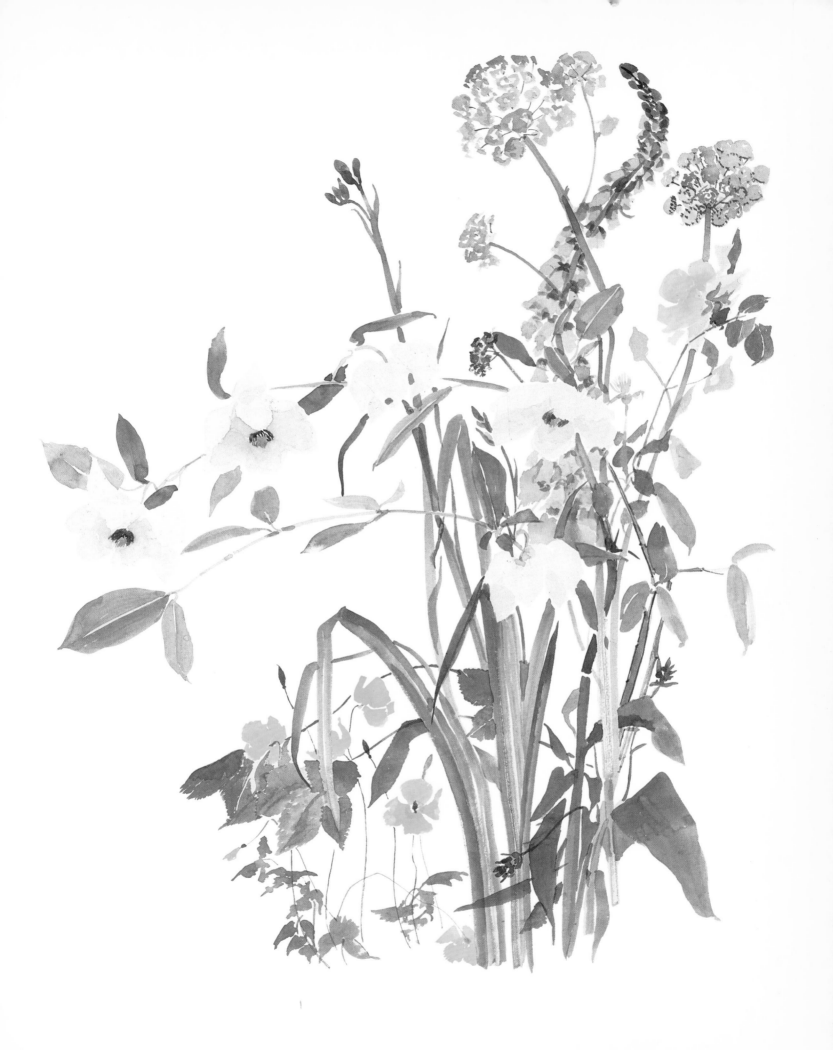

PERPETUAL CARNATIONS

Carnations are one of the oldest of the flowers we grow, but familiar as they are, they never seem really native. There's something so different about them, which is perhaps the reason why we use them so frequently on festive occasions. They are fascinating in every respect. Their blue-green or sometimes silvery foliage forms thick tufts. The flowering stalks are tiered and bear branching lanceolate leaves up the entire stem and the flowers have a distinctive crisp look, a convolution of crimped picot-edged petals heavy with their peculiar clovey scent. Their colour range is endless — whites, creams, pastels and self-colours that are often so dark they have a velvety quality.

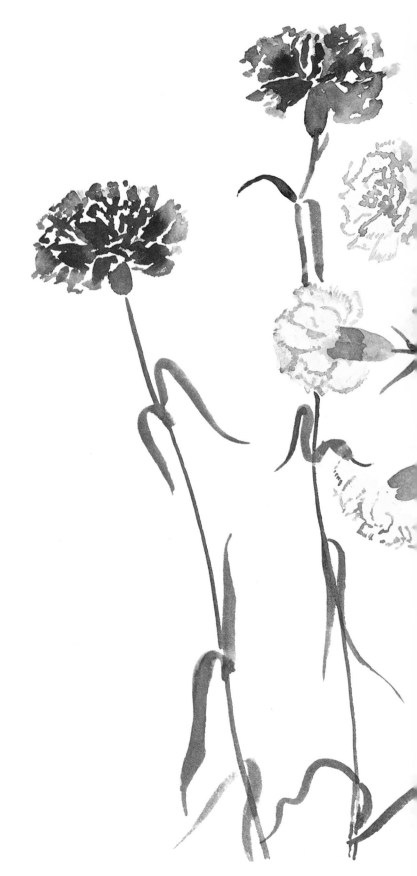

Carnations, cultivated forms of *Dianthus caryophyllus*, are a 'florist's flower', i.e. one developed to meet commercial demands. They used to be divided into groups. Those in which the flower showed broad stripes of one or two colours going right through the petals were called 'Flakes'. If the stripes were of more than two colours, they were classed as 'Bizarres': 'Painted Ladies' had petals of red or purple but white on the underside, and those with toothed and coloured edges to the petals were 'Piquettes'.

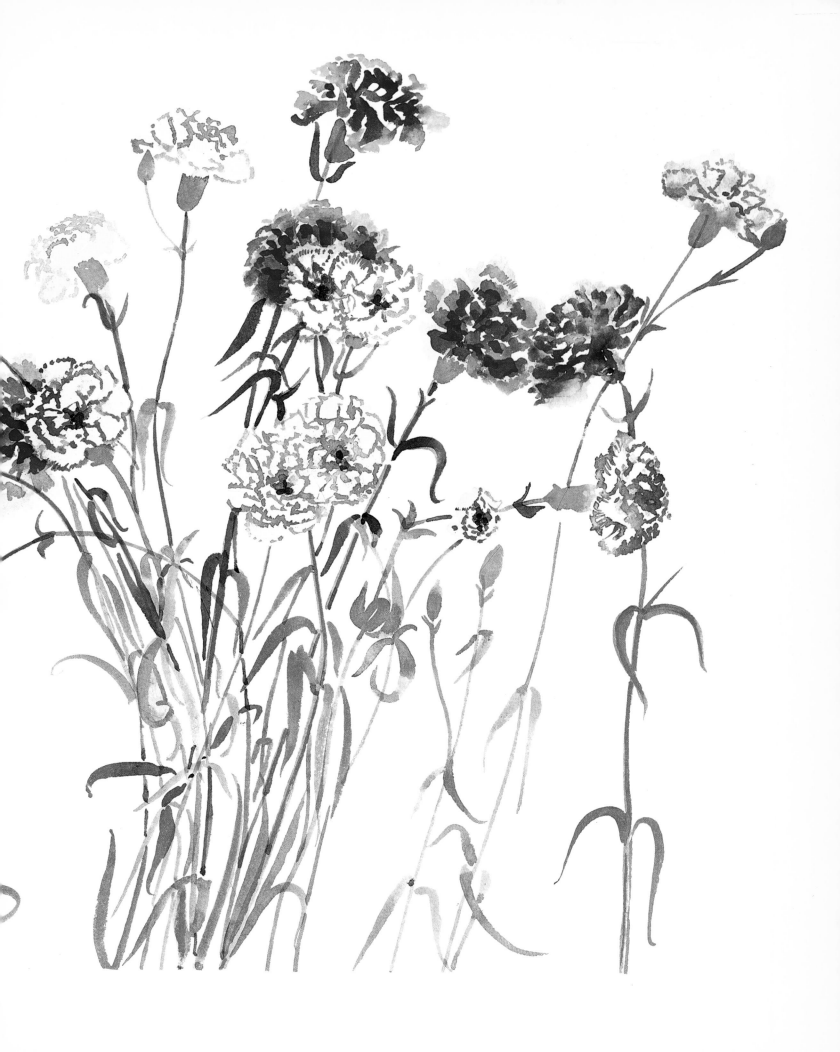

POPPY MIX

Poppies are excitement. They must be the magician's flowers. Growing them is constantly surprising as they rarely come true from seed. It's marvellous to see their bowls of eye-stinging colour, emblazoned with shining darks, floating high in the air like paper kites.

Shirley Poppies are the creation of one man, the Reverend W. Wilks, who in 1880 noted among a group of the Common Red Poppy (*Papaver rhoeas*) in a wild part of his garden, a single flower with the petals slightly margined in white. 'I marked the flower', he says, 'and saved the seed, which the following year produced about two hundred plants, four or five of which had white-edged petals. The best of these were marked, their seed sown, and the same process of selection and elimination was repeated for several years . . . until a pale pink form was obtained followed by a plant with white flowers. Next I began the long process of changing the centres of the flowers from black to yellow, and then to white, until I finally succeeded in obtaining a group of plants with petals ranging in colour from brilliant red to pure white . . . all the flowers having yellow or white stamens, anthers and pollen and a white centre.'

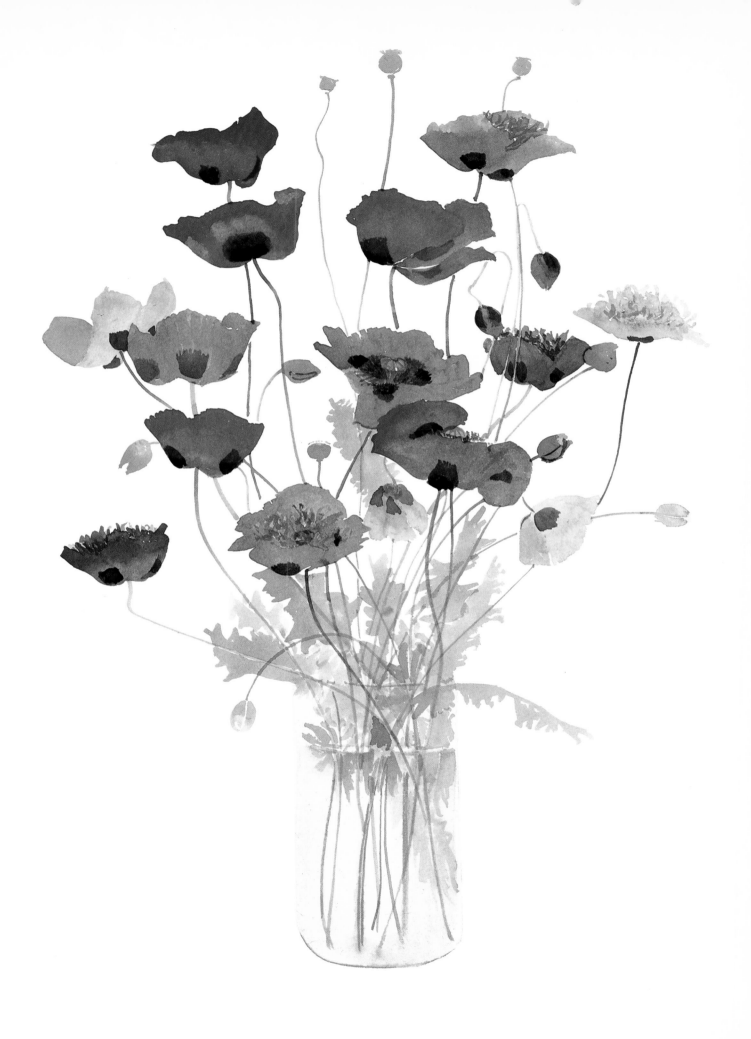

LILIES AND CORN MARIGOLDS

The modest Corn Marigolds picked while walking in a nearby field did not appear remotely incongruous mixed with the grand Limelight Lilies. Their daisy-like heads, in their simplicity, provided a perfect complement to the larger, very formal statement made by the lilies. The total effect was one of cool sunlight.

There are something like fifty species of *Lilium*, and a host of hybrids and garden varieties. They are bulbous plants native to the temperate regions of the northern hemisphere. The generic name of *Lilium*, taken from the Latin, is also common to almost all European languages, testifying to the length of time lilies have been esteemed. They are among the most beautiful of flowering plants and appear in pictorial form as early as Minoan Crete, in a fresco discovered in a villa at Amnisos which dates as far back as 1580 BC. The genus *Chrysanthemum* comprises several hundred species, of which only a few are cultivated in gardens. *C. segetum*, the Corn Marigold, is one of these, being a vigorous fast-growing annual daisy-like plant found in cornfields throughout Europe. The generic name *Chrysanthemum* is derived from the Greek *chrysos*, 'gold', and *anthemum*, 'a flower': *segetum* means 'of cornfields', i.e. 'the golden flower of the cornfields'.

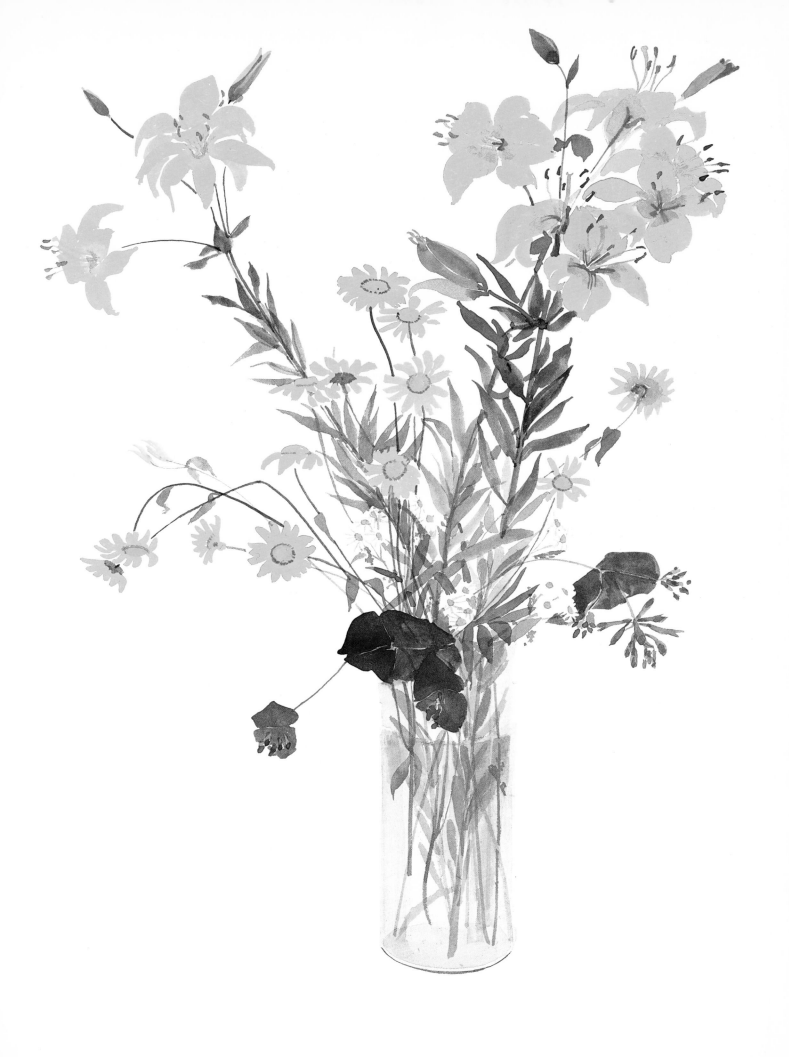

SWEET PEAS – FIRST CUTTING

The scent of sweet peas is the most evocative fragrance of early summer, conjuring visions of early evenings when the air is still and silence music. As growing plants they look unusual, scrambling upward to form a natural lattice of green stalks hung on tenacious tendrils, spotted with pairs of pale ovate leaves, and bright with delicate pea flowers, sticking outwards on long wiry stems. Flowering in shades of red, pink, white, magenta, purple and blue, they have an irresistably ethereal quality. Once cut and brought indoors, their prismatic colouring creates an impression of light.

Lathyrus odoratus, the ancestor of the sweet peas of our gardens, is a somewhat hairy native of Sicily. It has oval leaves and one-inch-long red and purple flowers that are intensely fragrant, more so than the innumerable varieties that have been bred from it. It was this strong fragrance that led to its being given its common name, the Sweet Pea, and it was for this it was first brought into cultivation, rather than for its flowers. The plant reached England at the end of the seventeenth century. It retained its strong fragrance throughout that century but, in the ensuing concentration on larger and larger flowers, with bizarre forms and greatly increased range of tints, the fragrance was largely bred out of it, until it is absent altogether from many of the modern plants, vastly superior though they are to the older varieties in every other respect.

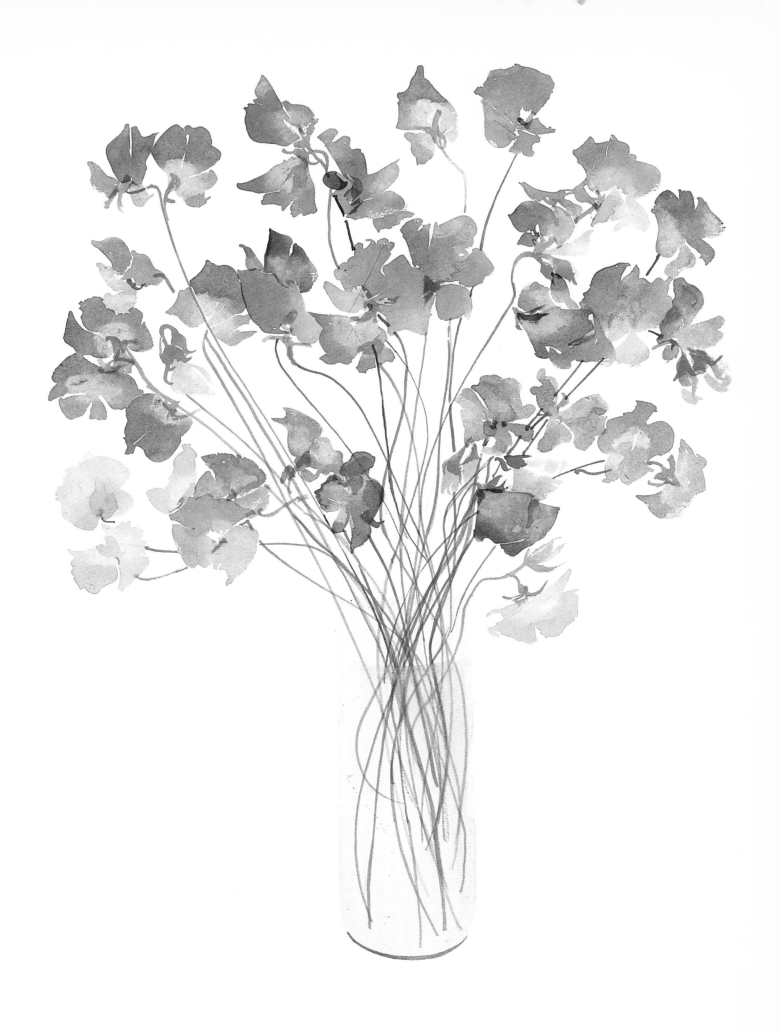

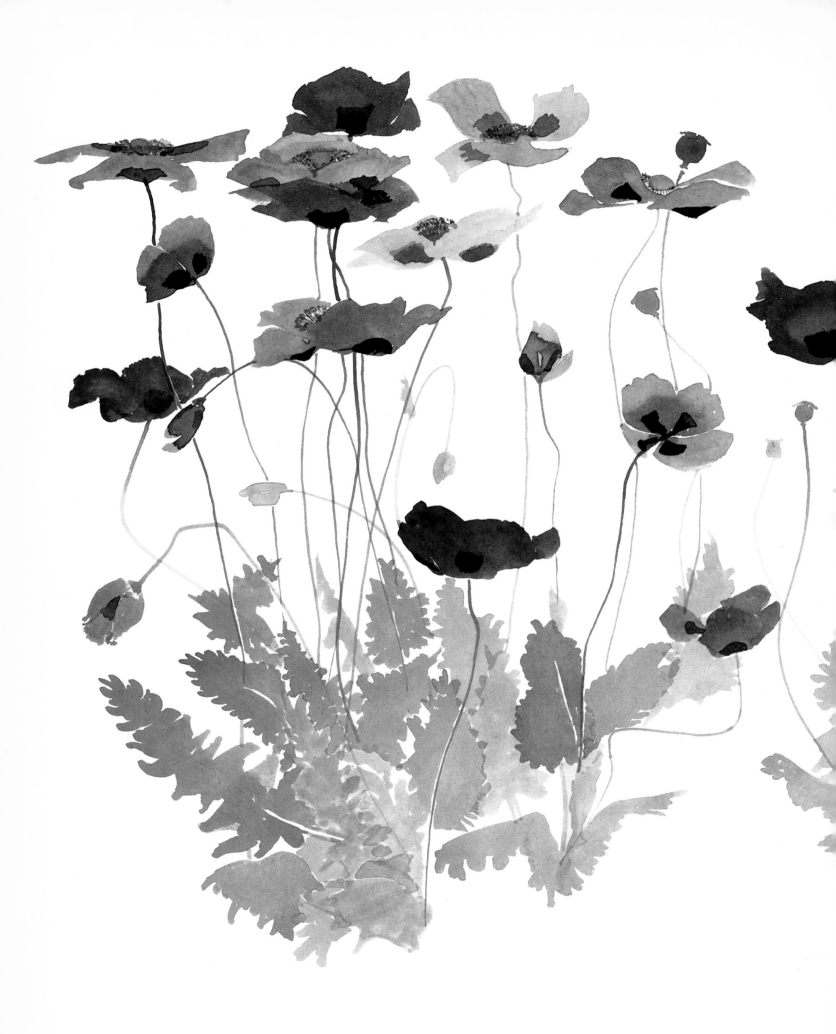

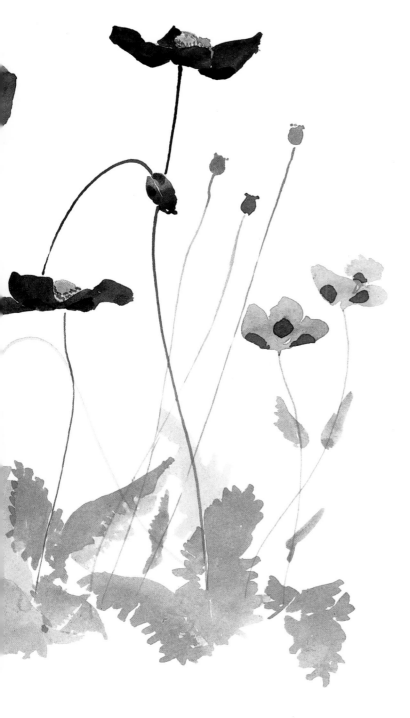

POPPIES – DEEP PURPLE

The flowers of the Opium Poppy are usually white, but those in England are more frequently found in innumerable shades of mauve and purple. Some are really so dark they have an aura of wickedness, echoing de Quincey's opium-fevered 'Confessions'. All poppy flowers have a distinctly alien, seductively foreign quality, quite divorced from any other flowers in the garden.

Papaver somniferum, the Opium Poppy, is found in Britain, but not as an indigenous plant. In many parts of the world this poppy is not grown for its ornamental qualities but for what may be obtained from it. Its seeds are edible and are used in many ways in confectionary. From the seeds, too, is obtained poppy-seed oil. It is the latex, however, which provides the most potent product, the opium that is used both medicinally and as an addictive drug.

SINGLE PEONIES

Newly opened peonies are breathtaking. Luscious, brimming with floweriness, their petals are a perfect shape, enclosing centres crammed with golden stamens. Sadly, their moment of perfection is short-lived. Flowers marvelled at today can already be past their best by tomorrow.

There are upwards of twenty species of *Paeonia*, a genus that belongs to the family *Ranunculaceae*. The generic name stems from Theophrastus, who noted that it was derived from Paeon, a disciple of Aesculapius the physician. The genus occurs in Europe, Asia and on the Pacific coast of North America. There are two types, those that are herbaceous in habit and those that tend to be shrubby or woody. Of the herbaceous species, *P. officinalis*, which is native to Europe and flowers in April and May, is very widely grown in hybrid form, the original species, now rarely seen, having small single crimson flowers. A large number of hybrids and varieties has also been produced from *P. lactiflora*, native of eastern Asia, these being known as Chinese Peonies: they flower later, in June and July.

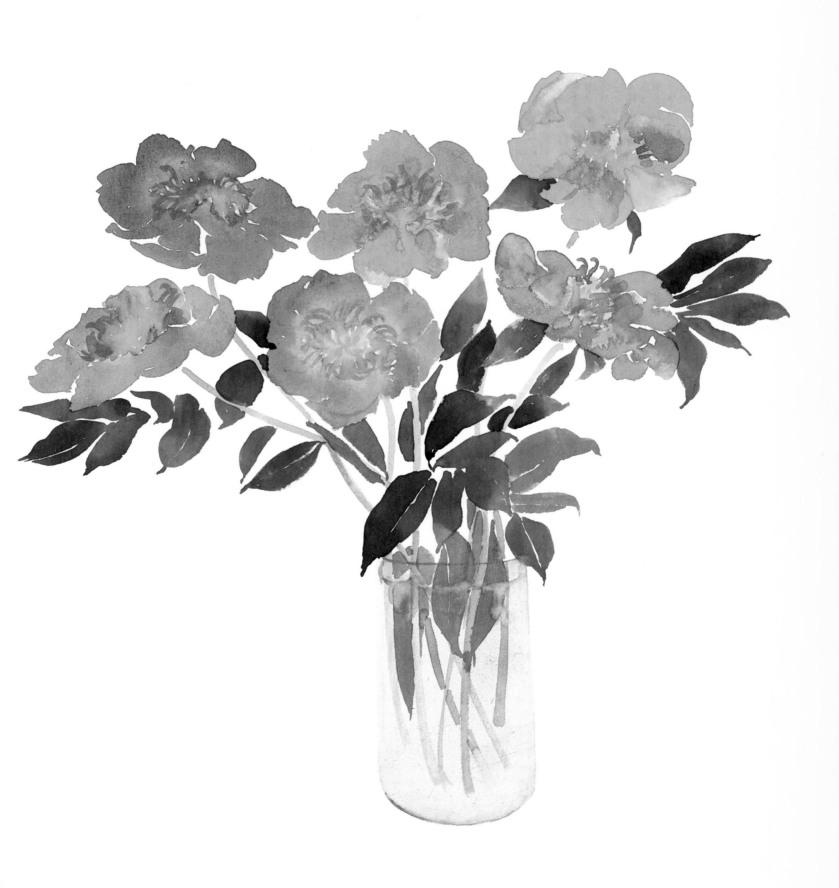

LUPINS AND DAY LILIES

The name 'Day Lily' has a dismissive ring, it implies an underlying criticism of the flower's short life. In reality they're amiable and rewarding to grow, reliably appearing each year with firm, shiny green strap-like leaves, their handsome, trumpet-lily flowers growing up erect from their midst. Budding in clusters, flowers fading are quickly replaced — a process that fortunately continues even when the flowers are cut. Their heavy scent has an eastern tang, providing the garden's first really exotic perfume of the year.

The genus *Hemerocallis*, of the family *Liliaceae*, is native to the Far East and southern Europe. There are many species, among them *H. aurantiaca* from Japan, formerly itself a popular garden plant but now superseded by the numerous hybrids bred from it and other species, including *H. altissima*, also from Japan, which has been used by hybridists to introduce height into the crosses, as the species grows up to eight feet tall. *H. thunbergii* has also been cultivated for its late flowering, coming into bloom in July and August. The generic name *Hemerocallis* is derived from the Greek *hemeros*, 'a day', and *kallos*, 'beauty', referring to the short-lived nature of the flower. *Lupinus polyphyllus* of the family *Leguminosae* is the chief parent of the lupins now grown in gardens. George Russell developed from this the Russell Lupins which have such an astonishing range of brilliant colours and mixtures.

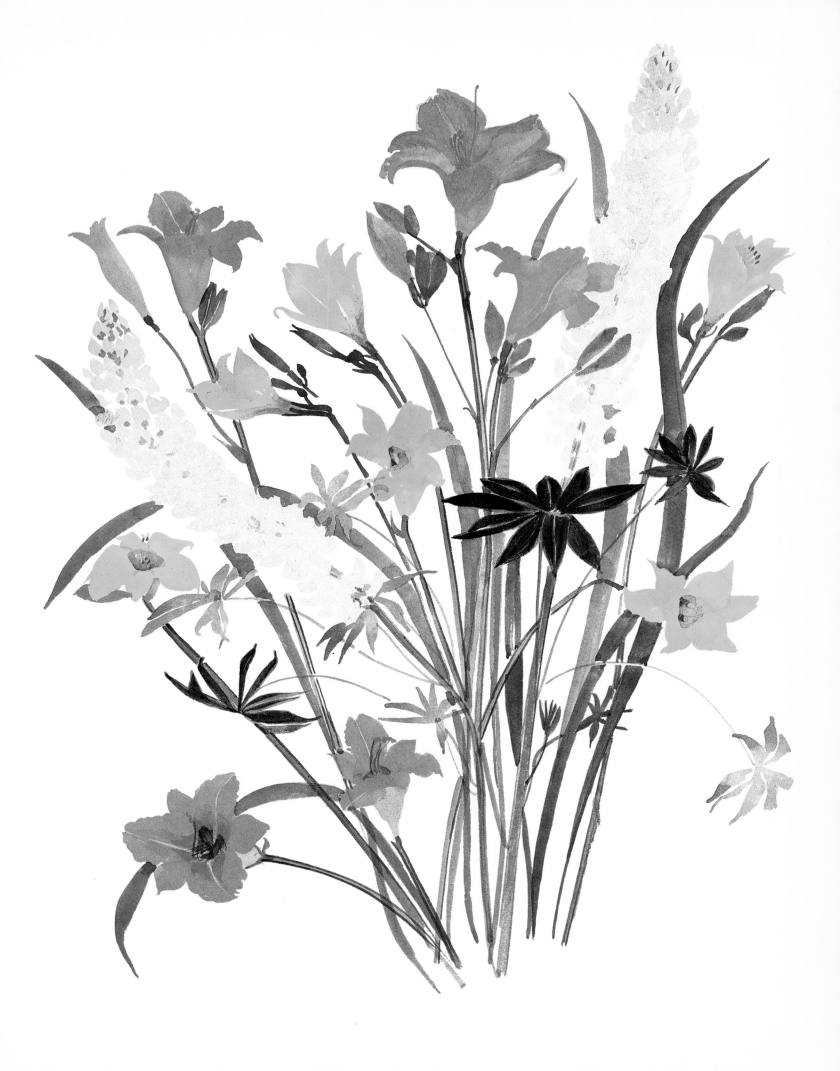

LAVATERA – SPLENDIDLY PINK

Lavatera is the poor man's hibiscus. Bountiful beyond expectation, its prolific flowering is truly astounding. Within a season a plant with a single stem will grow into a shrub with a virility that is nearly tree-like. Its exuberantly flowering mauve or pink-mauve trumpets, open almost visibly to produce a fanfare of colour. On examining the flowers more closely, an additional toning from the magenta veining is apparent on the butterfly-wing petals. Each flower's five petals surround a central pistil of cyclamen pink dusted with silvery pollen.

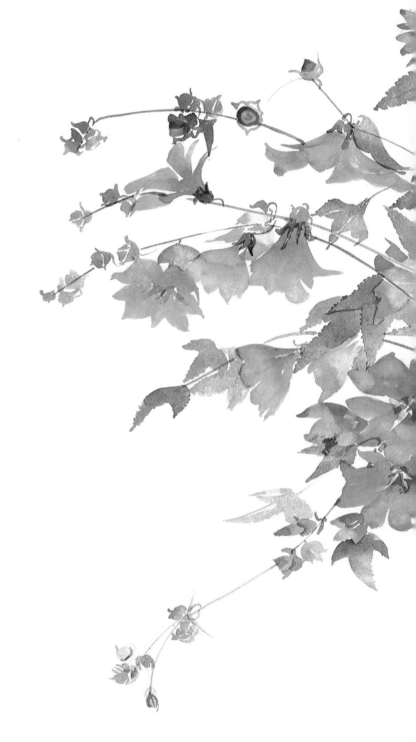

The genus *Lavatera* of the family *Malvaceae* contains about twenty-five species. They are found as far apart as the Mediterranean regions, the Canary Islands, Australia, Central Asia and California. Only a few, however, are in cultivation. *L. arborea*, the Tree Mallow, is a vigorous perennial or biennial semi-herbaceous plant native to southern Europe which flowers prolifically from April to July, bearing flowers four inches across in terminal racemes. It flourishes particularly well in seaside localities on poorish soil.

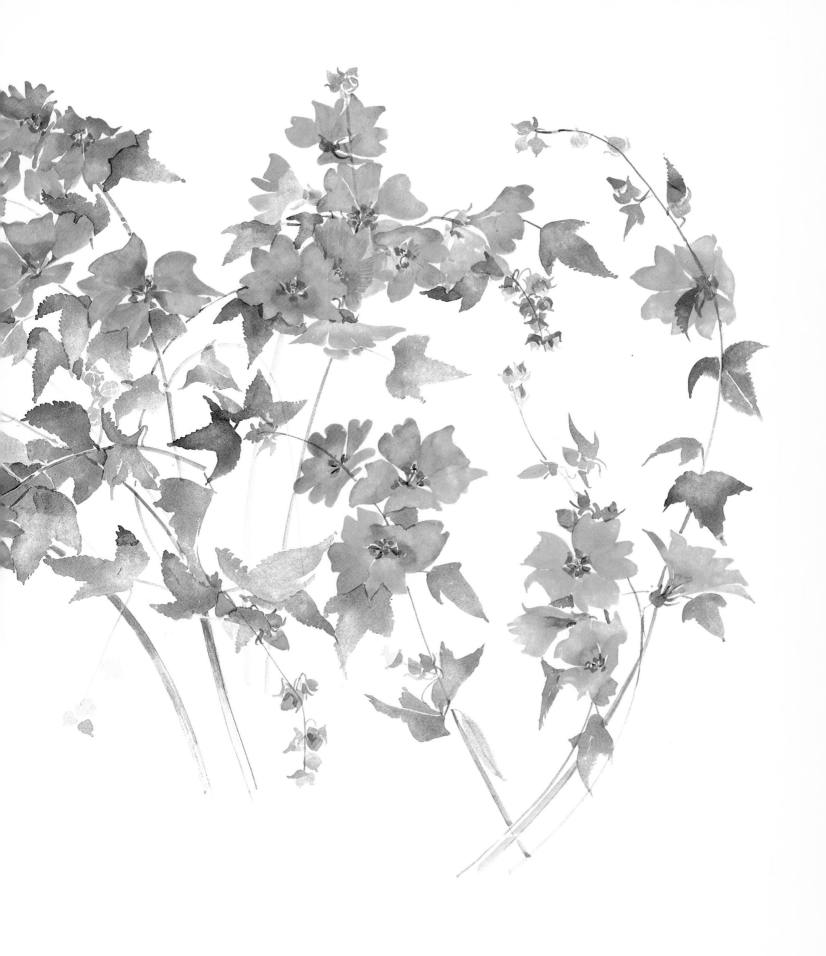

CHINA ROSES

I saw this variety of rose growing in a garden in Shanghai. There, they were a revelation — bigger, fuller, and of a more saturated colour than their English counterpart. Looking at Chinese gardens with European eyes, the immediate impression was of a lack of flowers, hence the impact of these roses. Later, when I came to paint similar ones from my own garden, I couldn't help recalling those seen in China, the fusion of images making a Chinese influence in the paintings inevitable.

The influence of China upon modern garden roses in the West is of long standing and goes back to the very beginning of the movement that produced the roses of today. Up to the end of the eighteenth century all the roses available in the West had a short summer flowering period and, apart from the Autum Damask, which produced a few flowers later, were then over for the year. Then, quite dramatically, came the break: four tea-scented roses were imported from China that had long been in cultivation in Chinese gardens and that carried in their genetic make-up the factor of continuous flowering. Crossed immediately with existing strains, various hybrids were produced that went through many more changes and vicissitudes until the crossing of what were called the Hybrid Perpetual and the Tea strains, from which evolved the first roses of the modern kind.

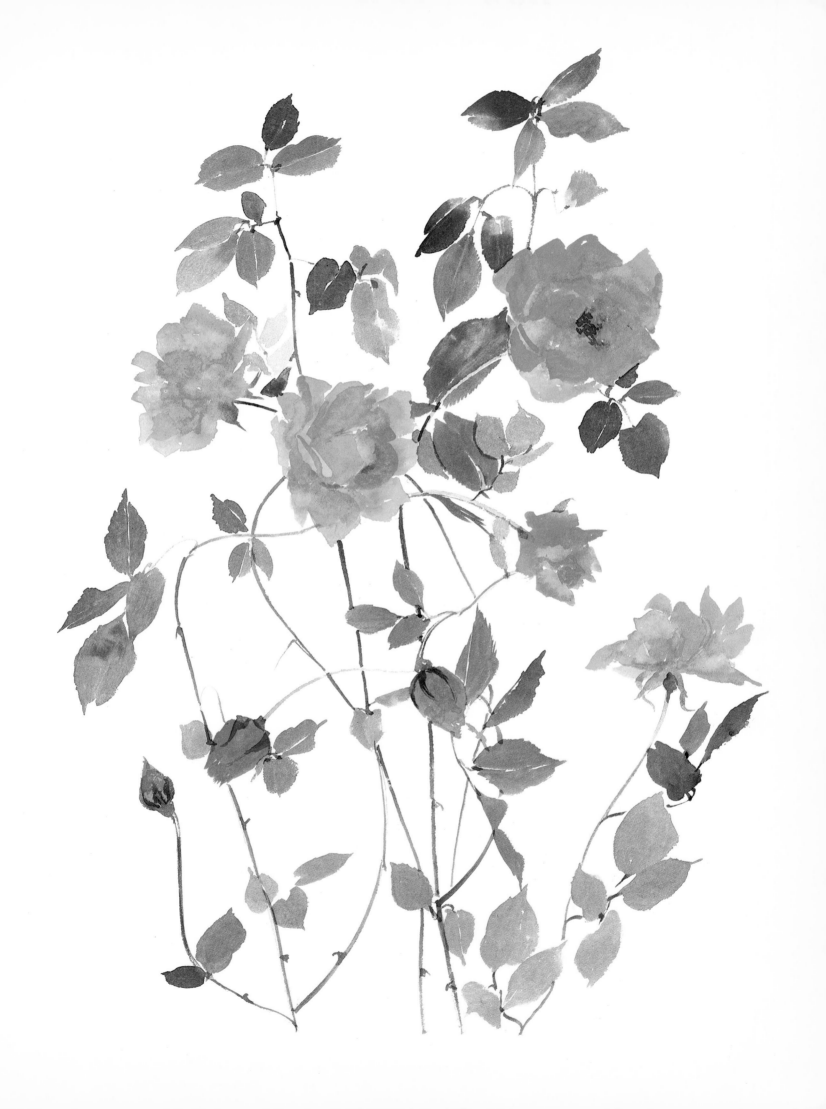

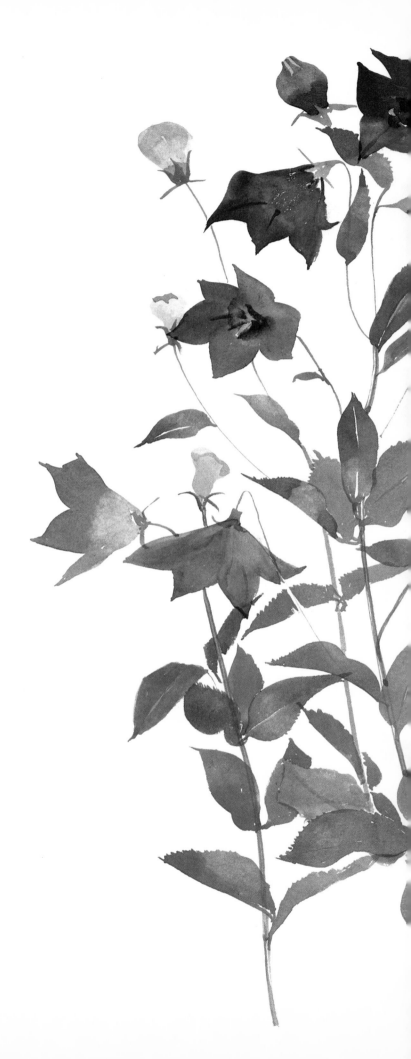

BALLOON FLOWERS –
OPENING

*I wonder whether the Balloon Flower was first seen
in Europe depicted either in a Chinese painting or
on a Japanese woodblock print. It was a plant much
favoured as a subject by the artists of both
countries. When seen growing, there is an austerity
about it that sets it apart from its neighbours.
Coming into flower, the buds appear inflated,
almost as if they are holding their breath, making
the balloon form that gives the plant its name.
Once open, the sharply pointed petals make stars of
a most marvellous blue. Perhaps it was seeing these
flowers contrasted against a white background that
was the beginning of the oriental preoccupation
with blue and white.*

Platycodon grandiflorum of the family *Campanulaceae*, called the Chinese (or
Japanese) Bellflower as well as the Balloon Flower, is found in the wild
throughout the Far East. It is generally thought to be the only species in
the genus *Platycodon*, although there is a naturally occurring variety called
P. grandiflorum var. *mariesii* which has larger flowers and is of dwarfer habit
than those originally discovered. This is the one that is generally grown in
gardens. The generic name *Platycodon* is derived from two Greek words,
platys, 'broad', and *kodon*, 'a bell', descriptive of the flowers, which, when
fully open, have a characteristic corolla of wide bell shape: *grandiflorum*
means 'large-flowered'.

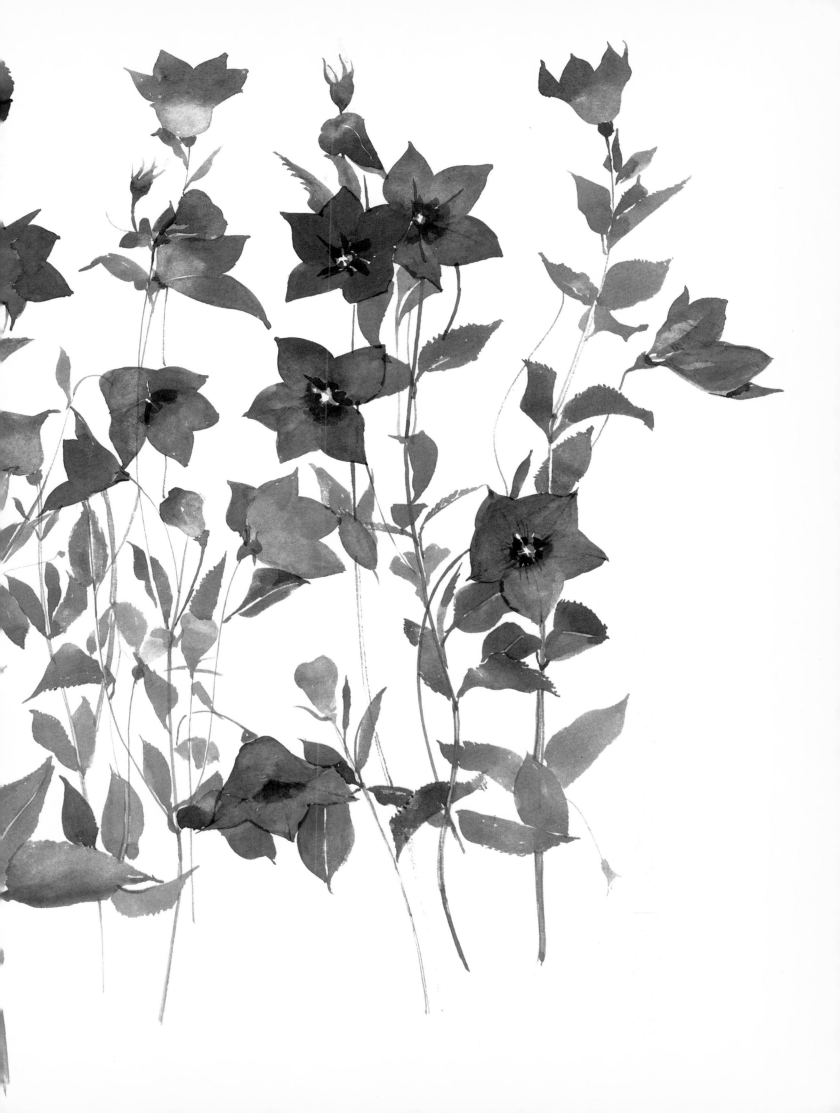

MORNING GLORY

Each year the Morning Glory's distinctive blue comes as a complete surprise, it has a legendary quality, like the blue of the Midi. With its determined runners that sprout soft green leaves, it seems to climb a wall as rapidly as a spider. The trumpet flowers are yellow and white where they join the stem, opening out into their peculiar, fantastic blue — a colour so exquisite that we forgive their lasting only through the daylight hours. This is a plant so elegant and special one forgets its family is the bindweed.

The genus *Ipomoea* to which the Morning Glory belongs comprises several hundred species scattered throughout all the warmer areas of the world, more being found in America than anywhere else. The genus belongs to the family *Convolvulaceae*. The generic name is derived from the Greek *ips*, 'bindweed', and *homoios*, 'like', referring to its twining habit. The popular Morning Glory, cultivated as an annual in northern gardens around the world, although it is a perennial in its natural habitat, is *Ipomoea tricolor*. Other species widely grown are *I. nil*, from the tropics of the Old World, and *I. purpurea*, native to tropical America, the species from which most hybrids have been bred. The Japanese have for centuries been expert cultivators of the *Ipomoea*, treating the growing of these plants, as they do some other plants, as an art. The vogue for them reached its peak there in the 1830s.

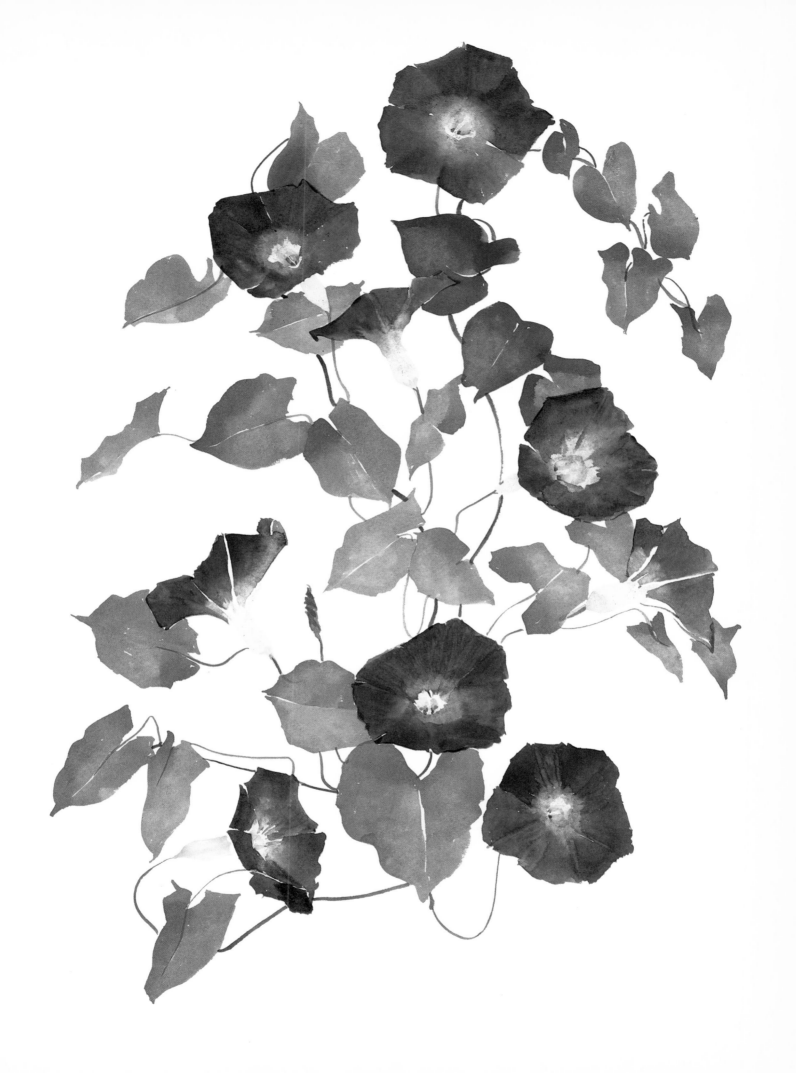

LUPINS –
PUNKY PINKS

Lupins have a long history. They originated in ancient Egypt and featured in Roman cuisine. This edible aspect was underlined in 1917, when Dr Thomas, a German professor, organized a banquet in Hamburg, at which every course and even the coffee and liqueur contained lupin. Most architectural in form and enormously colourful, they make a noticeable contribution to our gardens, flowering densely in steeple-like spikes of tightly packed pea-flowers. Their prolific flowering stimulates cross-pollination, resulting in countless shades, often bi-colours. The decorative digitate foliage could easily be a flower in its own right, and is so reminiscent of papyrus it is easy to believe the lupin once grew by the Nile.

Lupins take their generic name *Lupinus*, according to some, from the Latin: it was used by Virgil and Pliny and is supposed in that case to come from *lupus*, 'a wolf', because of an alleged propensity to destroy the fertility of the soil. The number of *Lupinus* species runs into hundreds, nearly all of them to be found in an area extending from the southern part of the northern hemisphere down to Chile. Lupins may be used as crude clocks to tell the time of day as, even though the weather is cloudy, the leaves constantly follow the course of the sun.

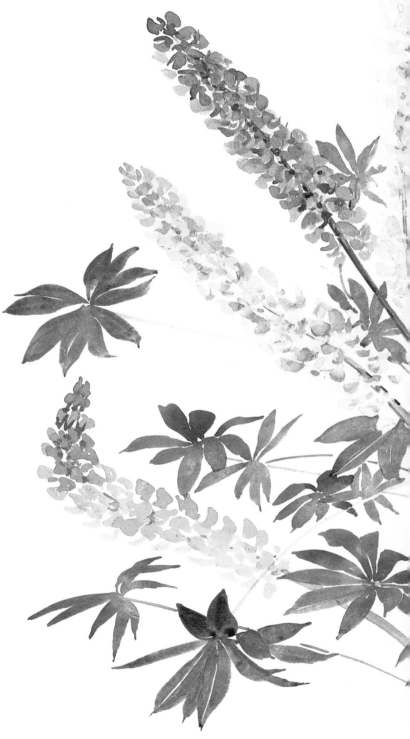

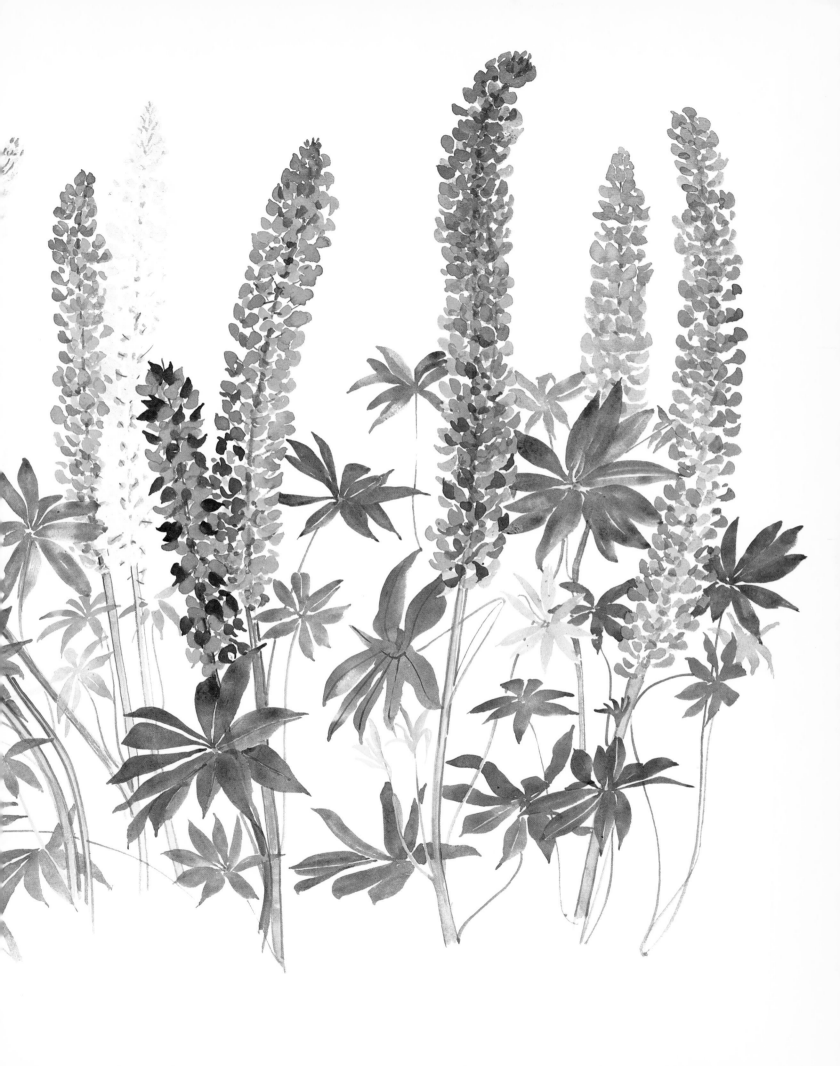

PORTLAND ROSES

The rose, whether as a shrub, climber or rambler, is bound to be found growing somewhere in every garden. Roses are such personal flowers. In bud they seem rather secretive, but open their entire beauty is revealed — unfolding ever more generously, until they reach their zenith, when the petals, with almost a sigh, detach themselves and fall soundlessly to the ground, silken soft and still sweetly perfumed. Roses are perfectly matched by their foliage, whether coloured green or a surprising bronzy red. The older varieties are especially marvellous to encounter unexpectedly thriving in some corner, so long-established their name is forgotten.

The history of the original Portland Rose is somewhat obscure. It is known to have been in a Paris nursery in 1809 and that it was obtained from England and named by the nurseryman after the Duchess of Portland who had probably brought it from Italy. In England it was called *Rosa paestana*, or 'Scarlet Four Seasons', the epithet *paestana* meaning that it had come from the neighbourhood of Paestum. In colour, it was a bright red verging on scarlet and cared for properly could be induced to flower both in summer and in autumn, indicating that one parent was probably *R. damascena* var. Autumn Damask. Another strain in its ancestry may have been what was called the French Rose (*R. gallica*). It also seems likely, from the colour and dwarf habit of the Portland Rose, that one of the foundation roses imported from China, 'Slater's Crimson China', had also found a place in its pedigree.

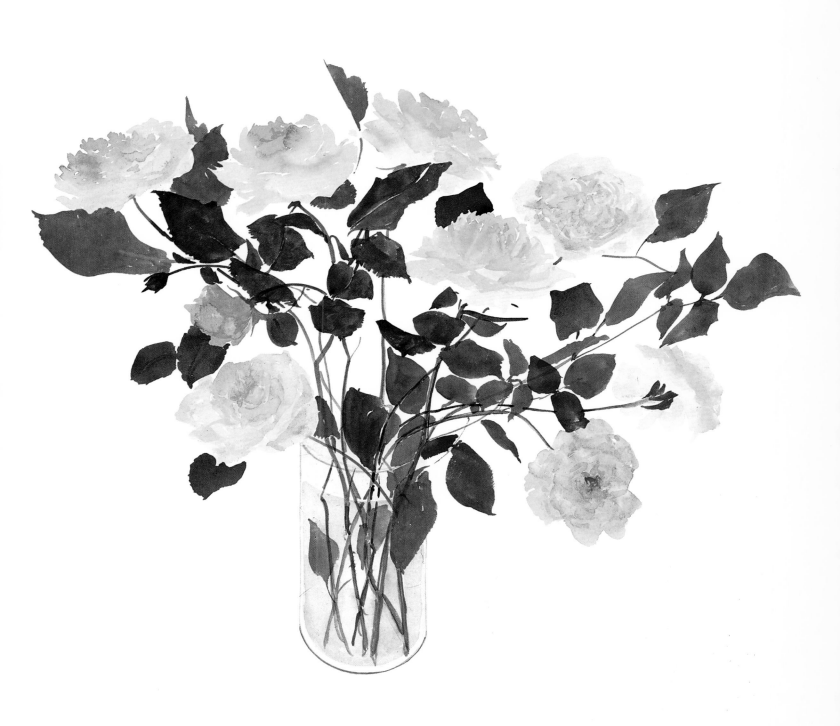

BOUQUET FOR BAKST

This is flamboyance with no punches pulled, a mixture of high summer flowers in magenta purples, flame reds and rosy pinks — that clash almost audibly. Despite the familiarity of the flowers — roses, gladioli, lavatera — the overall effect is exotic, with an opulence that recalls Scheherazade.

Cosmos, the Mexican Aster, is a genus of the family *Compositae* of which between twenty and thirty species are found in the United States, Mexico and Bolivia, the plants usually found in gardens being hybrids of the annual *C. bipinnatus* from Mexico. The name *Cosmos* stands for beauty, orderliness and a sense of symmetry, but the plant itself is unruly, establishing itself at random.

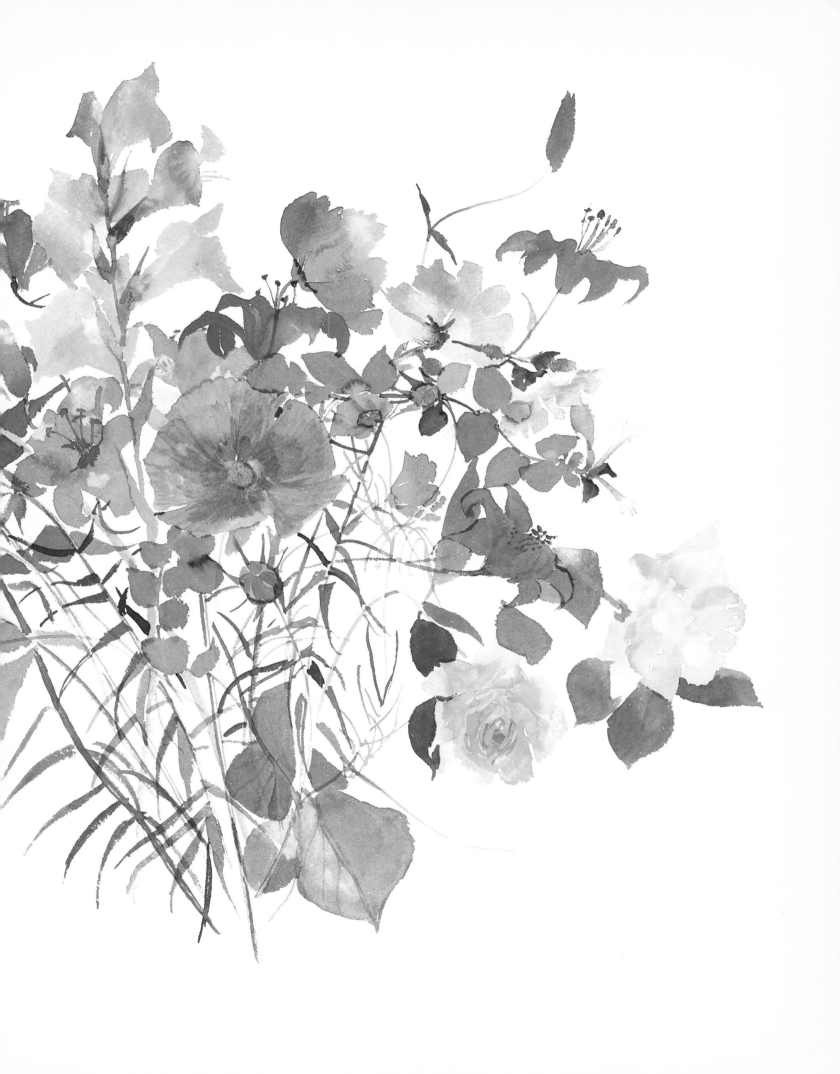

HIGH SUMMER FLOWERS
WITH WHITE BEGONIA

The garden in high summer is brimful of colour when everything has grown to its maximum and flowers are at their peak. The enormous abundance and diversity makes crazy and unusual groupings feasible. Gladioli are balanced here by lavatera and hydrangeas. The begonia was so magnificent it could not be omitted and its whiteness is intensified by the colour contrasts.

The genus *Begonia*, member of the family *Begoniaceae*, was named after Michel Begon, a seventeenth-century administrator of the French West Indies and Canada. There are many hundreds of species and thousands of varieties, all the plants in common cultivation being hybrids, often with very complicated pedigrees. There are two main strains, the tuberous and the fibrous-rooted kinds. The tuberous-rooted begonias are mostly derived from crosses involving four South American species, *B. boliviensis*, *B. pearcei*, *B. rosaeflora* and *B. veitchii*, and *B. socotrana* from South Africa. All these were introduced to Britain in the second half of the nineteenth century. The fibrous-rooted varieties are derived from the annual *B. semperflorens*.

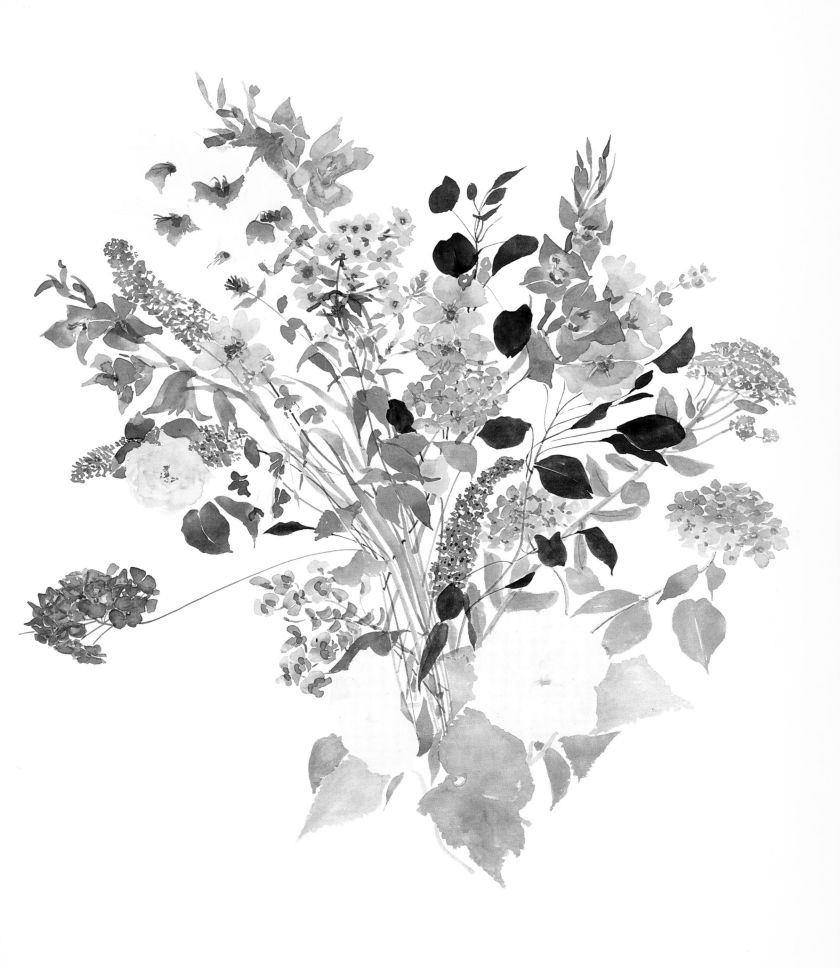

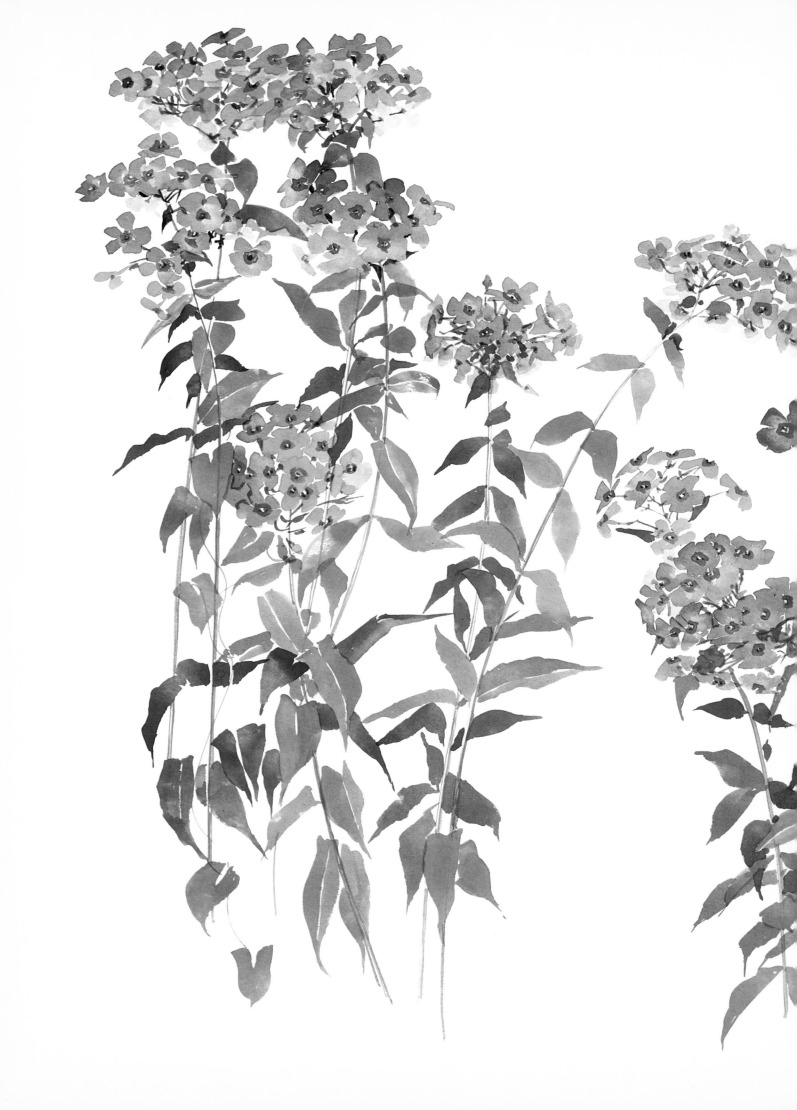

PHLOX – CHANGING PINKS

Phlox in flower indicates summer. These are plants with a hard, geometric character, their flower heads faceted knobs of separate flowers opened firmly flat, with centres outlined in a deeper vivid tone of the petals' hue. Colours can be livid, giving the flowers a rather unnatural appearance as if dyed – even the white variety is almost crystalline. The plants grow upright on rigid stems with dark green, dagger-shaped leaves. The scent is distinctive, acrid and penetrating – qualities exploited in perfume-making for, like musk, it can add pungency and persistence to other scents.

Phlox reached England from America in the mid-eighteenth century, the two species from which the modern varieties have been bred, *P. maculata* and *P. paniculata*, arriving in 1740 and 1752 respectively and becoming immediately popular. The genus, however, spreads its range wider than this type of plant. *P. drummondii*, native of Texas, is a decorative much-grown annual with many varieties. There are also attractive dwarf, prostrate and trailing species. *P. subulata*, native of dry meadowlands in the United States, is one of the best of these.

HOT SUMMER MIX

As season follows season, there is an identifiable metamorphosis in the actual quality of the colour of the flowers in bloom. Midsummer is distinguished by the pinkest pinks and infinitely varied reds, which provide marvellous, harmonic colour combinations as well as lighthearted discords and startling tonal contrasts. At a time of such profuse flowering it is easy to indulge in big joyous mixtures that breathe the warm air of halcyon summer days.

Species of *Buddleia*, named after the Rev. Adam Buddle, a seventeenth-century botanist, are found throughout the tropical and temperate zones of America, Asia, and South Africa. The one most usually grown in gardens in temperate areas is B. *davidii*, a native of China named after the Jesuit missionary and plant collector Père Armand David. A large number of attractive varieties have been bred from it. In England the *Buddleia* is known as the Butterfly Bush because of its attraction for butterflies, particularly Peacocks and Red Admirals. *Fuchsia* have been a favourite ever since the later years of the eighteenth century and from 1840 onwards they became a craze, being a particular favourite for hanging baskets. By 1880 there were no fewer than fifteen hundred named varieties and, although the number dropped off for a time, that total has since been substantially exceeded.

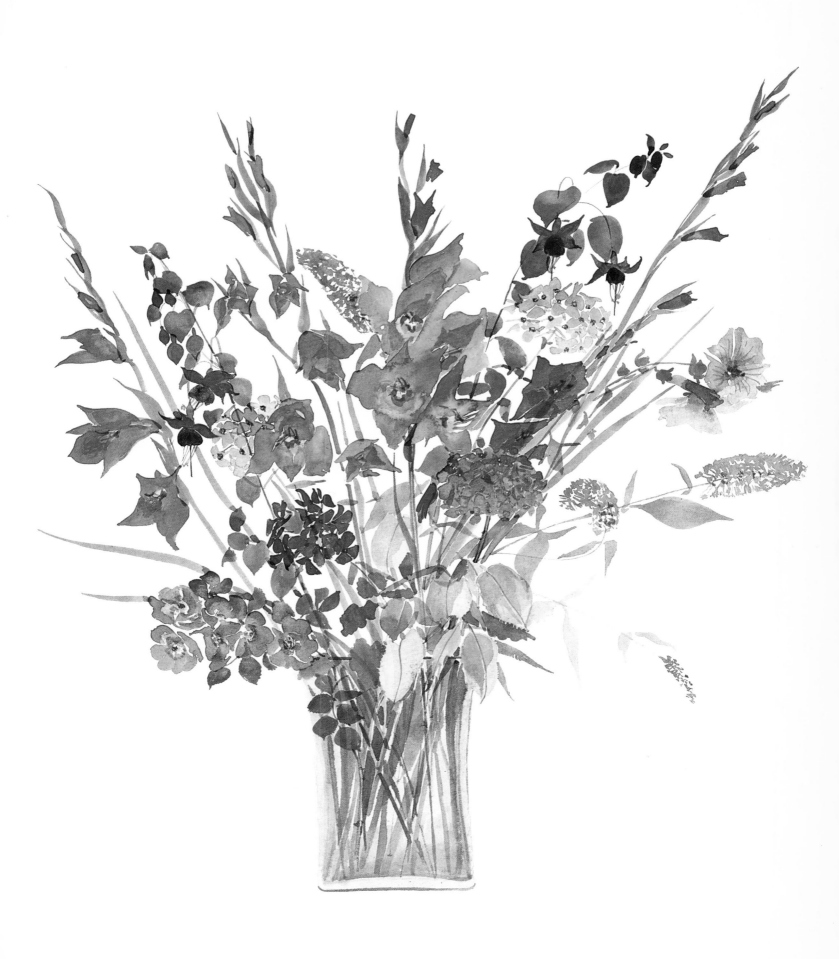

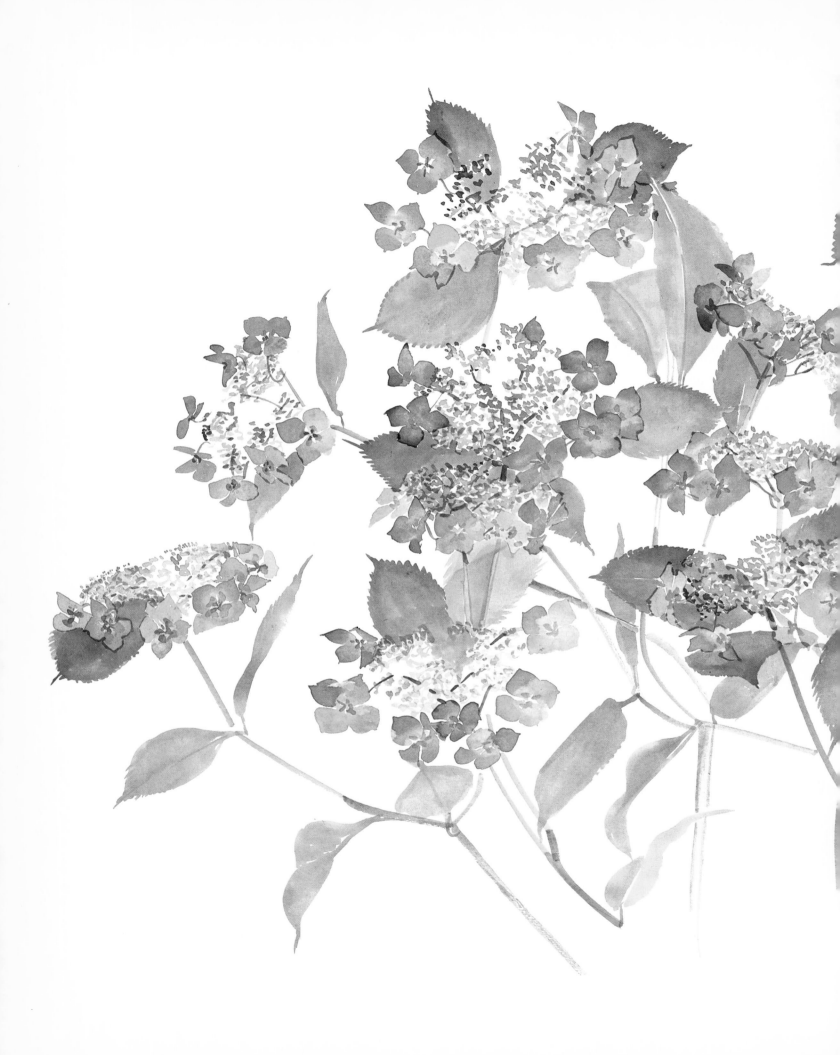

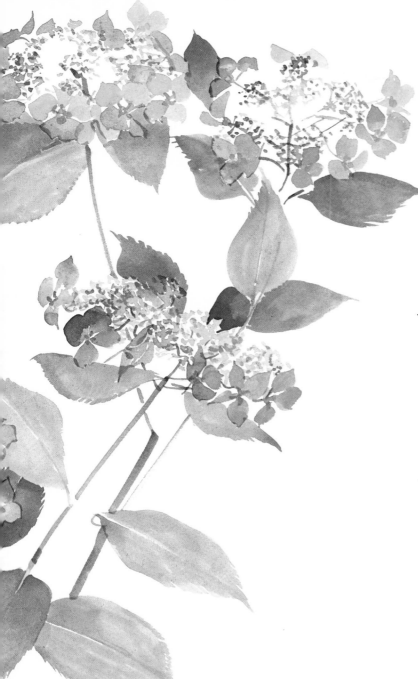

LACECAPS – A PINKER PINK

Many gardeners denigrate the Hortensia varieties as vulgar, but rhapsodize over Lacecaps. These flower in a more restrained way that displays their openwork structure. The flower heads are umbelliferous and are layered one on top of the other on the bush. The way the florets open intermittently around the edges combined with the lacy look of the centres reminds me of the decorative medieval snood headdresses of Pre-Raphaelite paintings.

Originally known as *Hydrangea macrophylla*, the Lacecap is more properly called *H. hortensis* var. *mariesii*, from the plant collector Charles Maries, who sent it from Japan to the nursery firm of Veitch and Co. in England in 1879. The outer flowers of the Lacecap are sterile. They consist of three to six colourful spreading sepals with the remnants of petals in the centre, and have no stamens or seed-bearing parts. Individual sterile flowers are often over three inches across, or even larger, the whole inflorescence being usually about eight inches wide.

GLADIOLI – FLAME FLAMBOYANT

Frequently awkward-looking in the garden, once indoors the gladioli's appearance can be miraculous. Exploding into flower after flower all along their stems, they have almost a surfeit of florescence. Cultivated in an amazing colour range, they can vary from snowy white and cream, through most shades of yellow and apricot, red, coral and pink to dark claret and purple. Gladioli give the biggest return of all bulbs, a concentration of flowers and colours unmatched in the garden.

Gladiolus, a name originally used by Pliny, is the diminutive of the Latin *gladius*, 'a sword' and refers to the shape of the leaves, like 'little swords'. The genus, which comprises several hundred species, is a member of the family *Iridaceae*. The species are found over a wide area from Central Europe, the Mediterranean region to central and south Africa, being particularly common in the area around the Cape of Good Hope. The wild forms first entered European gardens more than three hundred years ago but it was not until almost the middle of the nineteenth century that deliberately planned hybridization began and the impressive modern varieties and different strains began to be produced.

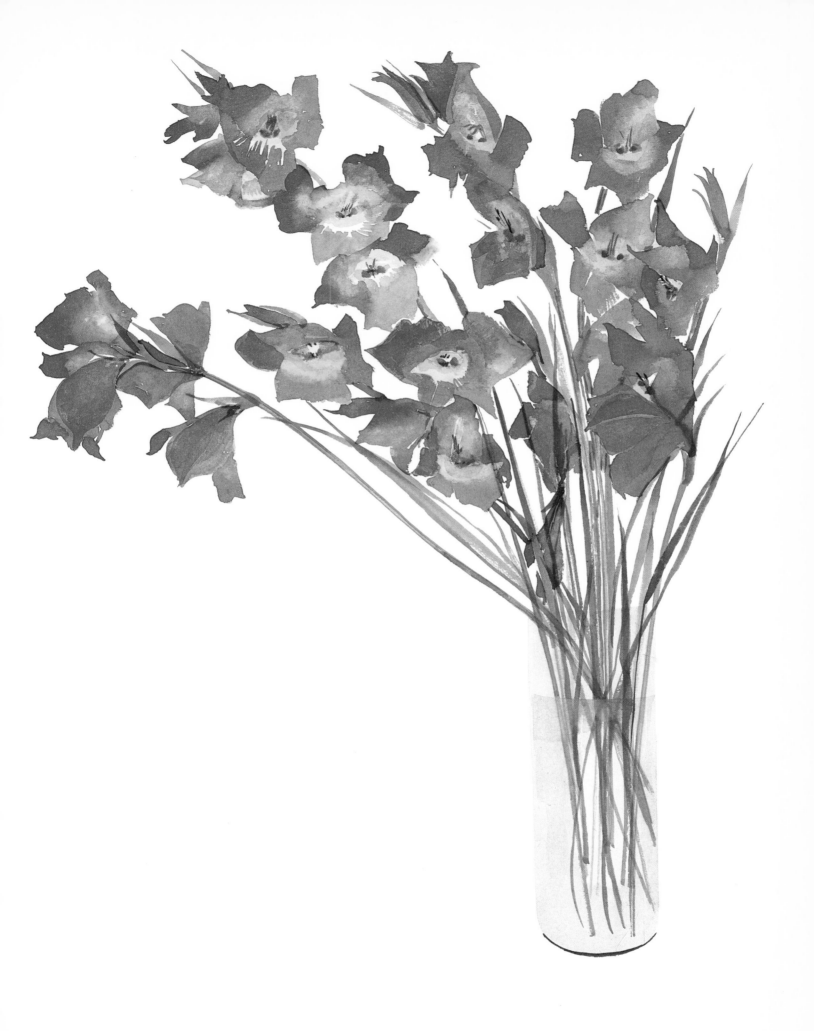

LILIUM SPECIOSUM
VAR. RUBRUM

The Japanese Lily retains its oriental looks and character despite being fully acclimatized to the West. Well-mannered in growth, its erect stems leave sufficient space between for each to carry its blooms uncrowded. Its blue-green foliage is discreetly arranged, the leaves spurring formally in pairs along the stems. The flowers are complex, with corrugated petals arching back on themselves, spotted and painted in rosy hues with tawny red and crimson accents. The pistil and stamens protrude conspicuously to counterbalance the petals. A genuine flower from the East, the lily contributes an aura of mystery and an exotic splendour to the garden.

Lilium speciosum fully deserves the epithet *speciosum*, which means 'showy', because the coloured markings on its petals contrasted against the basic white do indeed make it one of the showiest species of its genus. There are a number of varieties, with varying shades of colour marking, including a pure white form. In the variety 'rubrum', which means 'reddened', the dense zones of colour are accentuated, being red and crimson-scarlet. Introduced into the West in the nineteenth century, *Lilium speciosum* has since its arrival been one of the most popular of lilies, bearing from three to ten pendulous flowers, sometimes individually as much as five inches long, in a broad raceme on a stiff stalk. *L. speciosum* prefers a position in the sun, but abhors calcareous soils and, like all lilies, prefers to remain undisturbed: it should be moved only when the soil is exhausted.

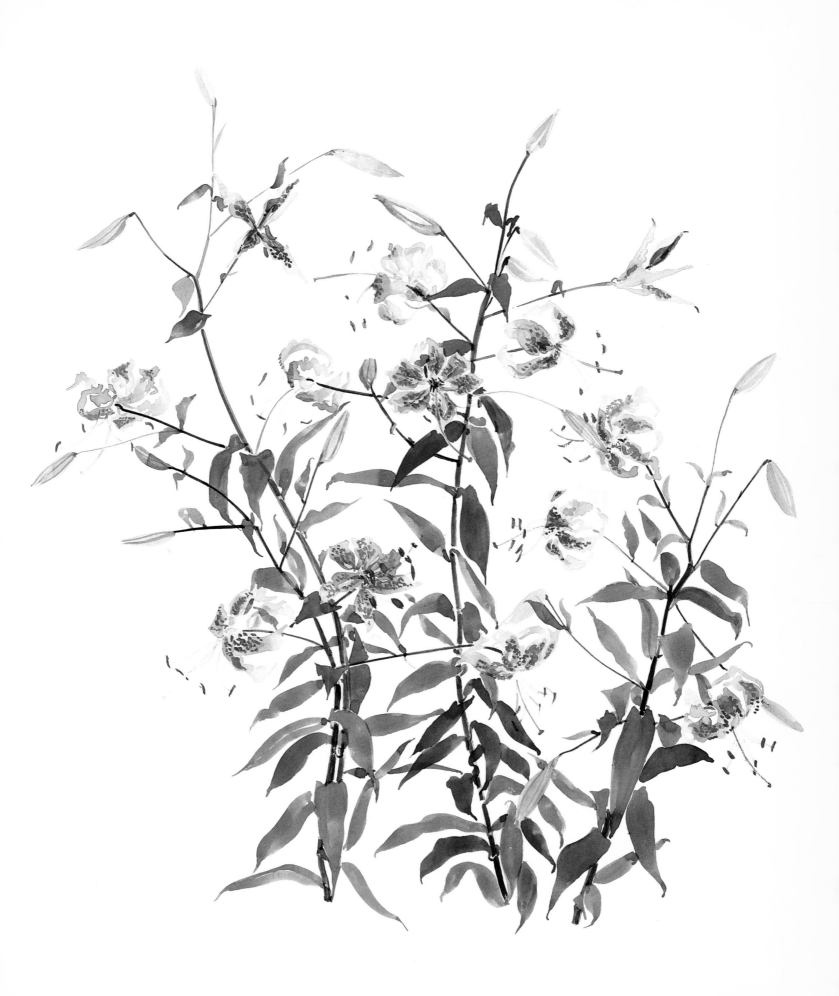

BLUE HIBISCUS

This variety, Bluebird, has petals shading from a deep, pure blue to violet blue, flushed with crimson and splashed with carmine around the centre. The very prominent pistil protruding from the centre like a miniature corn cob in appearance, looks out of scale. As the flowers fade they fold inwards, becoming bluer and quite bird-like. At any one time there will be flowers opening, fully open and waning, each of a different blue. A bush is decked with such a variety of blues, it could have come from a garden in a Persian miniature.

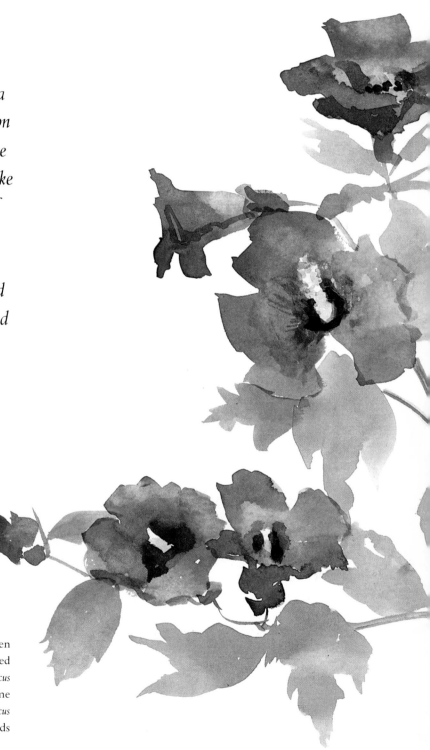

Hibiscus syriacus is a hardy shrub native to India and China, which has been grown in Britain for almost four hundred years, having been introduced from Syria, a fact that gave it its specific name. The generic name *Hibiscus* was used by Virgil for a mallow-like plant and it is thought that the name may come from ibis, a bird that the ancients believed lived off *Hibiscus* plants, species of which abound in the marshy places which the birds frequent. The genus belongs to the family *Malvaceae*.

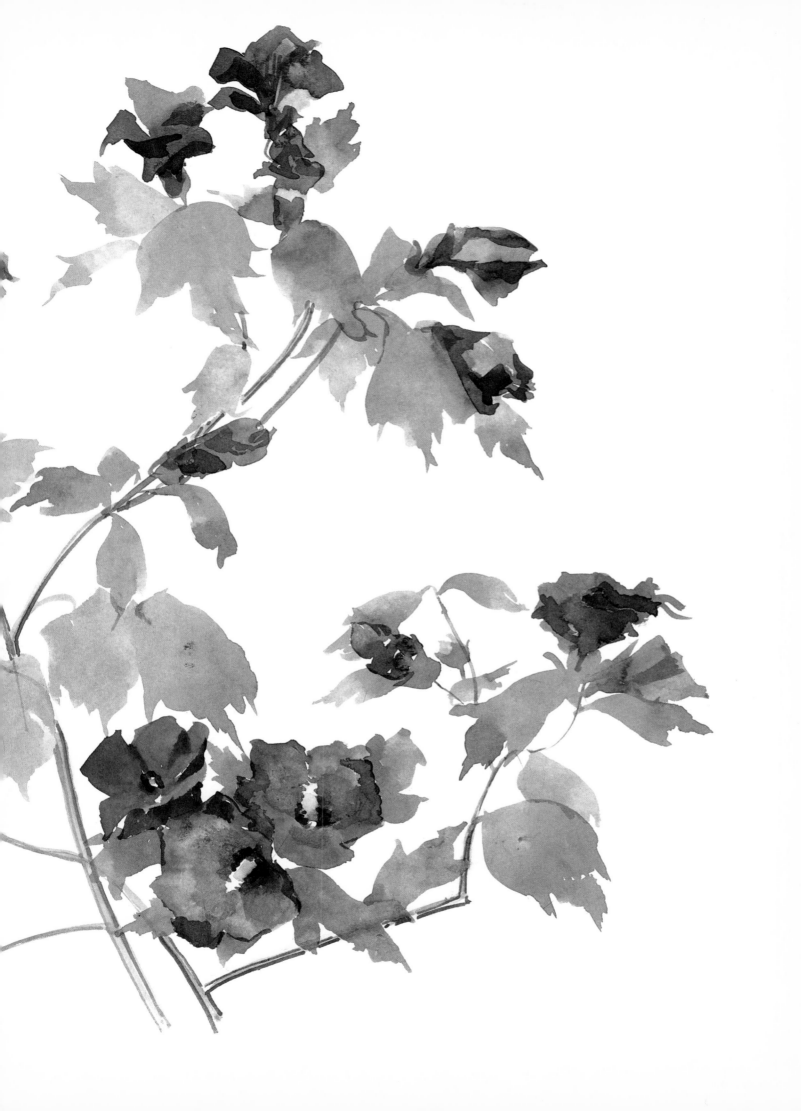

DAHLIAS – RED AND FIERY

My relationship with dahlias is one of the love–hate kind, they can be marvellous or nearly monstrous. These are flowers that need to be most carefully sited and controlled. Mostly big plants with large flowers, they shout for attention. Their many-petalled heads are fulsome, with a tremendous colour range that is sometimes extremely vivid. Mainly flamboyant, they can easily be vulgar. Wherever they grow, theirs is a forthright statement — you do not overlook a dahlia. Used well in the right herbaceous border they can be a source of wonder, but wrongly chosen, a disaster.

The genus *Dahlia*, of the family *Compositae*, was named after Andreas Dahl, a Swedish botanist who was a pupil of Linnaeus. There are comparatively few species of *Dahlia*, which are tuberous-rooted tender perennials native to the high mountain regions of Mexico and Guatemala. Although discovered by the Spaniards in the sixteenth century, species of *Dahlia* did not reach the rest of Europe until the late eighteenth century, being first cultivated in Spain. It was not long before growers discovered that, even though the species were few, they were very malleable and hybrids and varieties were very easy to produce. Sixty-two varieties cultivated in 1826 had risen to one thousand two hundred by 1841. Enthusiasm has continued unabated and many thousands more have been produced over the years, in all colours except blue and in innumerable variations of shape, petal form and size: some have flowers a foot across but there are others in which the flowers may almost be described as minute.

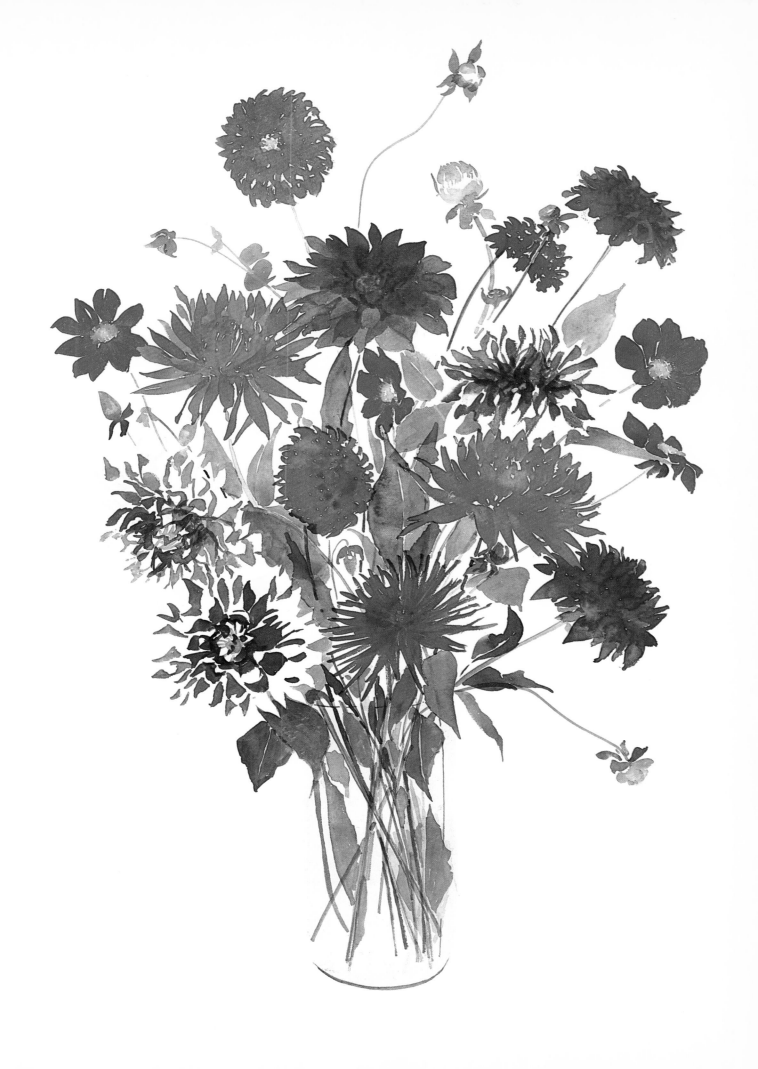

FROM A COTTAGE GARDEN

This hotchpotch of smaller kinds of flowers — dahlias, carnations and chrysanthemums, together with campanula, nicotiana and sweet peas — is so titled because it echoes the delights of those mixed bunches sometimes found for sale at cottage garden gates. Picked at random and put together without rhyme or reason, the haphazardness makes for some unexpected combinations — happy accidents such as yellow against sharp pink, or cornflower blue mixed with tangerine, mauve or lemon.

Chrysanthemum carinatum, a native of Morocco and an evergreen shrub in its natural environment, is cultivated as an annual in temperate gardens, being known under the name of *C. tricolor*. There are several hundred species of *Campanula*, which is a member of the family *Campanulaceae. C. persicifolia*, native of Europe, is a hardy herbaceous perennial from which varieties have been bred that are widespread in British gardens. The generic name *Campanula* is Latin for 'little bell' and *persicifolia*, also from the Latin, means 'peach-leaved'. There are more than eighty species of *Scabiosa*, Scabious, named from its alleged virtue of curing the itching disease scabies. The genus is a member of the family *Dipsacaceae. S. atropurpurea*, native to southern Europe, is a hardy annual species that has been cultivated in gardens for more than three hundred years.

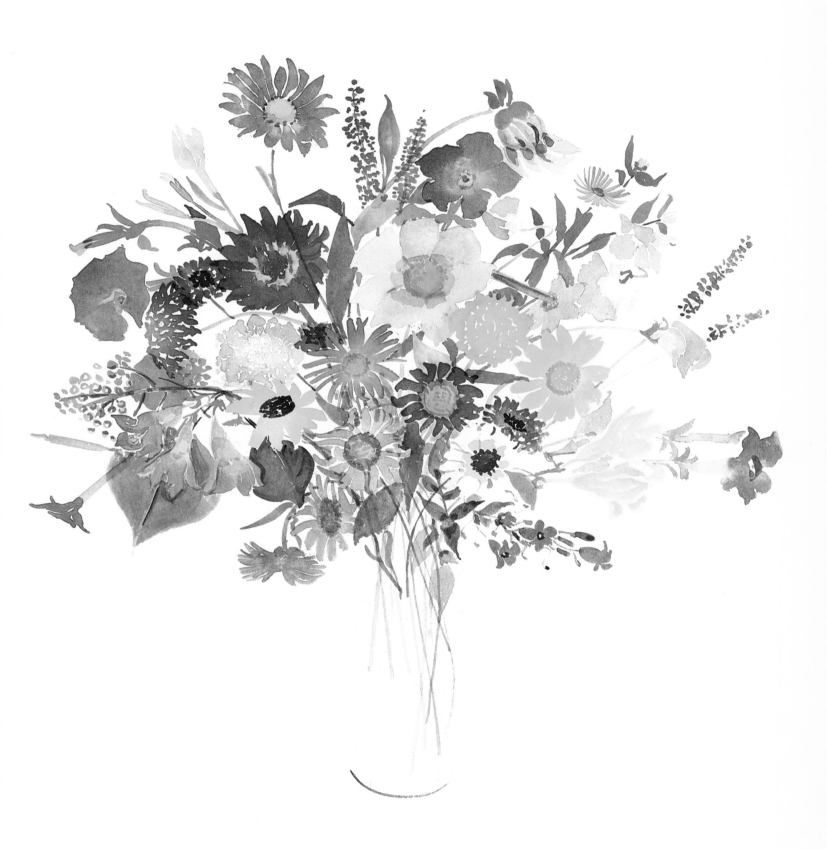

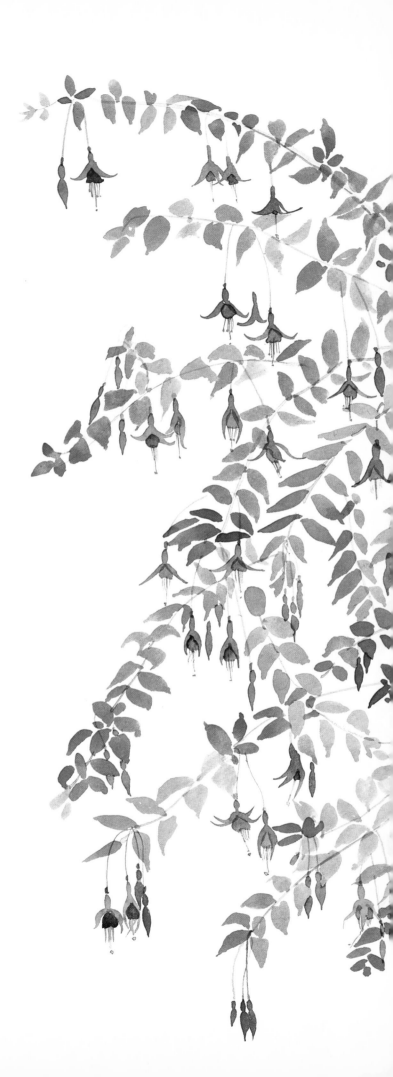

FUCHSIA MAGELLANICA

*The fuchsia's remarkable flowers look like
decorations rather than a natural part of the shrub.
Their shape is reminiscent of Chinese lanterns, and
their longish stalks give them the appearance of
being hung on. The arrangement of the flowers on
the branches is similar to the cherry, an analogy
repeated when it fruits. Look-alikes they may be,
but the fuchsia's fruits are disappointingly tasteless
— although they are mentioned as ingredients in old
cake recipes. Most fuchsias are too tender to
withstand frost but* Fuchsia magellanica *is
really hardy, as is demonstrated by this one
determinedly growing from a narrow crevice in an
old wall.*

Fuchsia magellanica is the hardiest of the genus. The basic species, *F. magellanica*
itself, is native to Chile, being found along the coastal strip near the
straights of Magellan and Argentina. There are several natural varieties
with distinctive characteristics. *F. magellanica* var. *conica*, also native to Chile,
has larger and more rounded buds but is less free-flowering than the basic
species. *F. magellanica* var. *discolor*, which comes from the Falkland Islands, is
the hardiest of all, forming a dense much-branched bush. *F. magellanica* var.
globosa, from Mexico, Peru and Chile, has stems that are leafless and curve
downwards, and *F. magellanica* var. *gracilis*, another native of Chile, is a
handsome plant which has several sub-varieties.

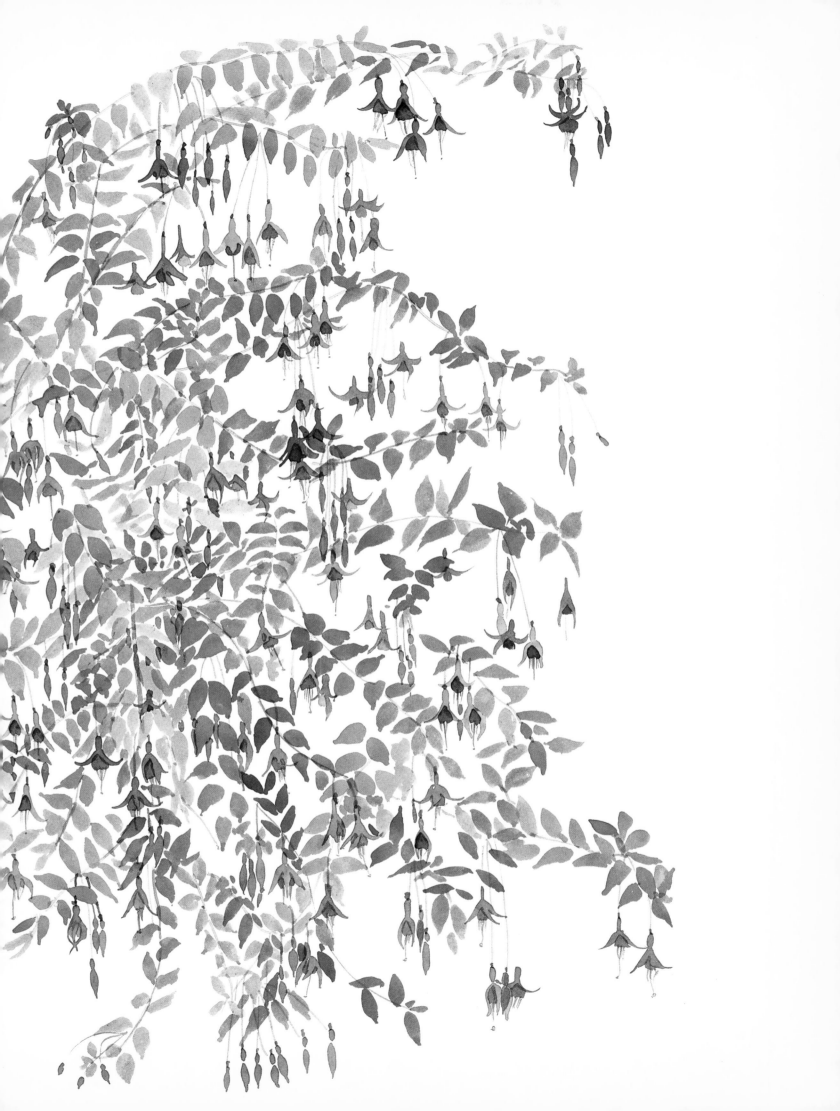

BLUE HYDRANGEAS

Both the Hortensia and Lacecap varieties have the capacity to produce flower heads of quite different shades on a single plant, which vary even more as they change colour with age. Initially sky blue, a bloom can deepen towards ultramarine or alternatively become distinctly green, sometimes as dark as malachite. These flowers, with their colours constantly changing throughout their long flowering season, continue to fascinate at every stage.

It was discovered as long ago as 1875 that pink flowered hydrangea plants produced blue flowers if the plants were watered with a solution of alum, or if iron filings were mixed with the soil. Hydrangeas will, in fact, turn blue in acid soil if they are able to absorb the iron in the soil. Chalk and lime imprison iron and aluminium so that, if the former substances are present the flowers will be pink. Modern treatments have been devised which enable the desired colour, either pink or blue, to be obtained in almost any soil. The process is, of course, facilitated if the varieties chosen to be grown are selected from those which have a natural tendency towards the colour which is desired.

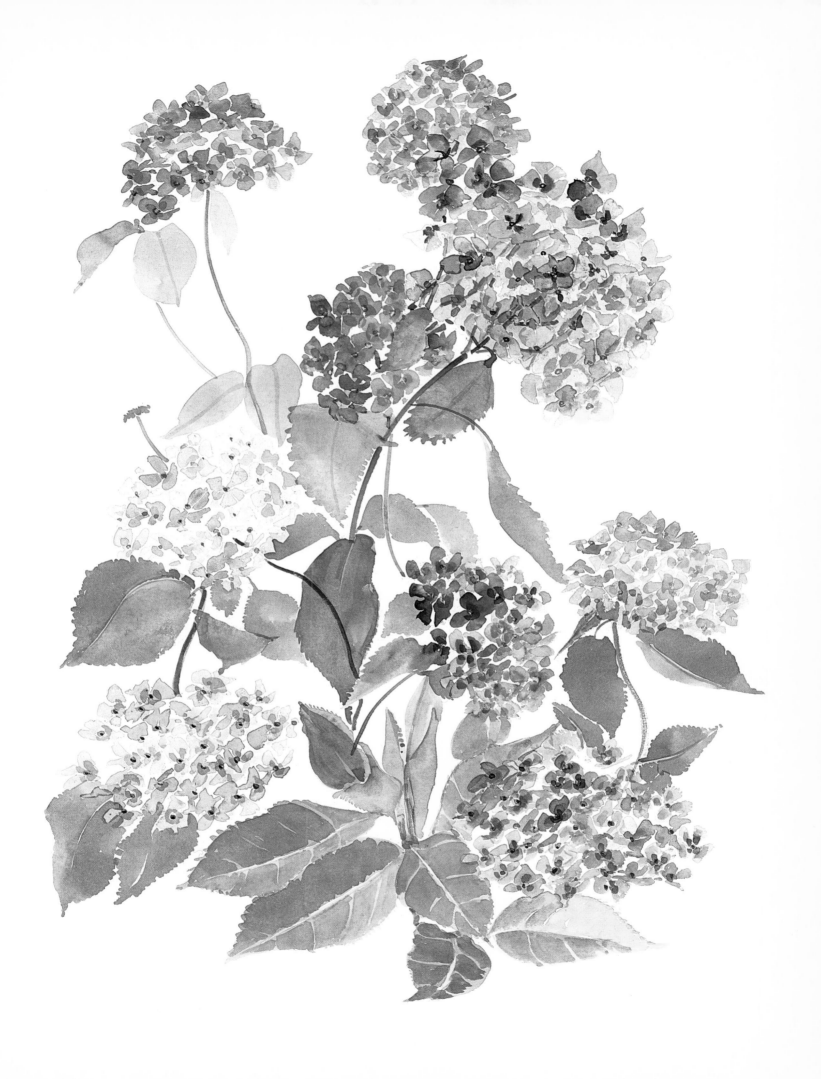

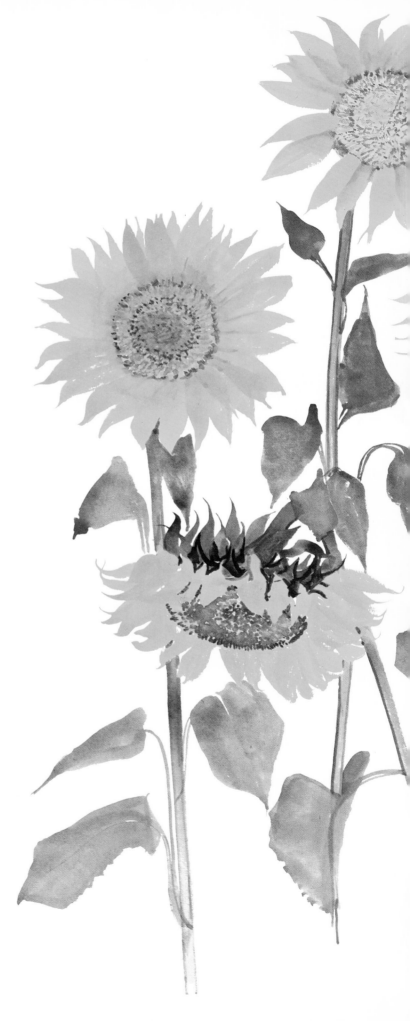

SUNFLOWERS – BURNING BRIGHT

Sunflowers originated in Peru where they had a revered place in religious rites, but they are now extensively grown for strictly economic reasons. Seeds, leaves and stems all have specific uses and are cultivated from modern varieties deriving from the United States and Russia. Often growing to twelve feet, the stems are so strong they lend credibility to the story of Jack and the Beanstalk. The flowers are at the very top — enormous, flattish discs crammed with seeds and surrounded by a fringe of petals, which, as they sprout from the flower head, give a flaming halo effect, recalling primitive representations of the sun.

The name *Helianthus* is derived from the Greek *helios*, 'the sun' and *anthos*, 'a flower', supposedly from an erroneous notion that the 'flower', really an inflorescence made up of many flowers, follows the sun, but more likely from the sun-like appearance of the very large yellow 'flowers'. The genus contains about fifty species and belongs to the family *Compositae*. The 'blooms' of *H. annuus*, the Common Sunflower, may be as much as eighteen inches across.

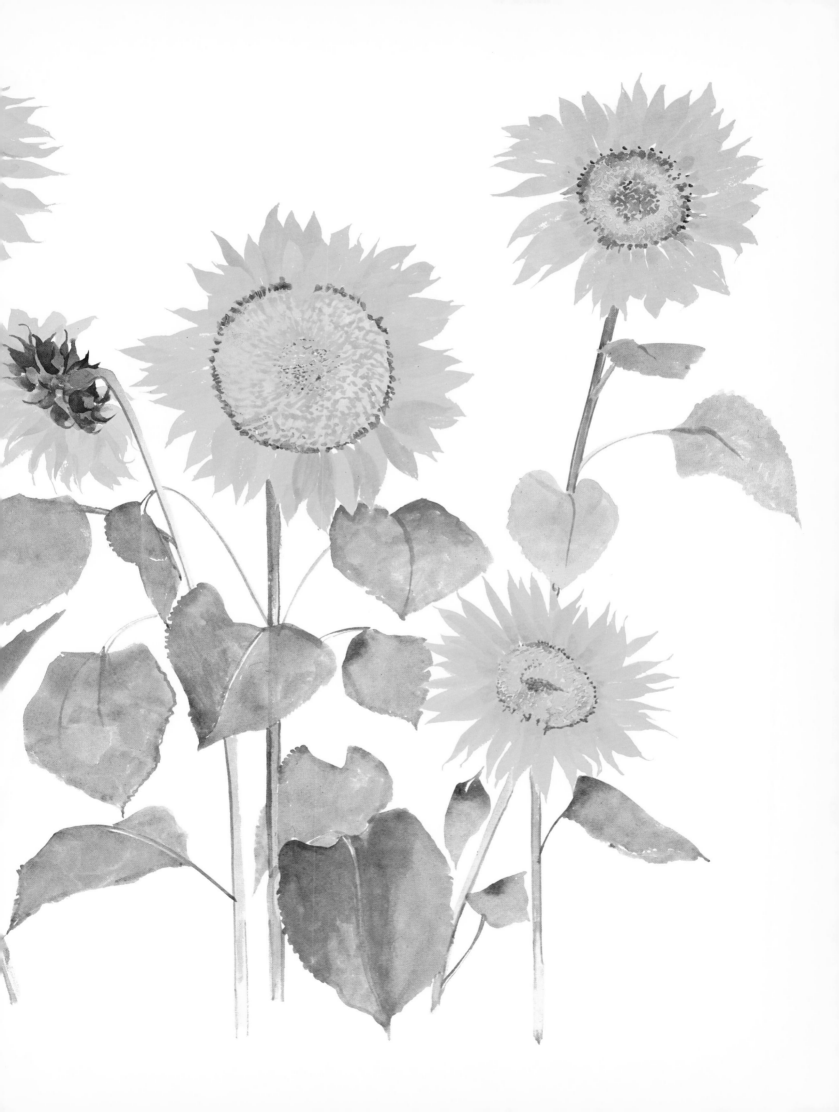

BELLADONNA – SOFTLY PINK

Late in the summer many plants look tired, even shabby. Now, with the flowering time over for so many, the Belladonna Lily's appearance is most opportune. Aloof and apart it rises up on a rhubarb-like stem, bursting into flower before any of its leaves appear – a ballerina assoluta, it commands attention. Serene and secure in its beauty, so prettily pink, it effortlessly seduces the eye.

The Belladonna Lily, in appearance resembling the Barbados Lily (*Hippeastrum*), is given by some a separate genus, *Amaryllis*, in which it is the only species. It is a bulbous plant native to the Cape of Good Hope growing three feet tall and carrying a magnificent head of flowers. The bulb from which the flower stem rises is pear-shaped, and since it is best left undisturbed it may, after eight to ten years, grow as large as a coconut. Each stem bears from six to ten pale-pink lily-like flowers. There are several beautiful varieties varying in colour. The name *Amaryllis* is that of a shepherdess referred to in the works of classical poets: *belladonna* means 'beautiful lady', certainly an apt comparison. *Hydrangea paniculata* is a species native to China and Japan. It is a hardy deciduous shrub that reaches fifteen feet high in the wild, but is not usually more than a third of that height in cultivation.

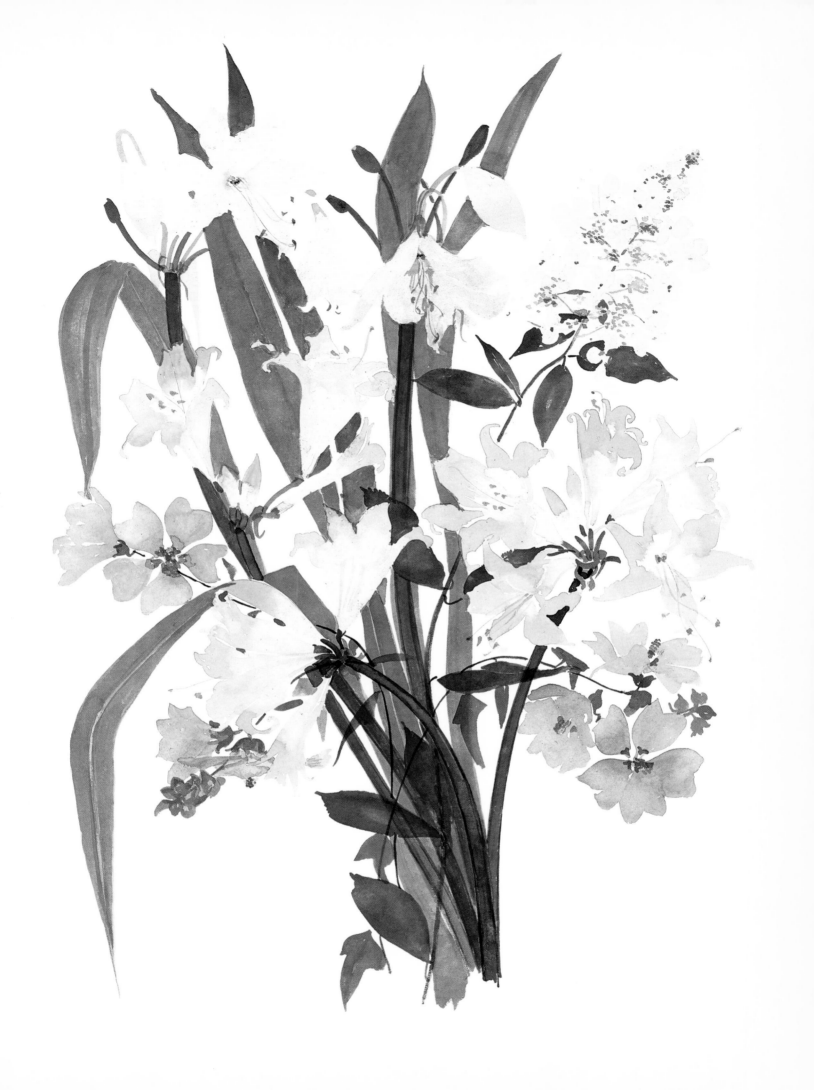

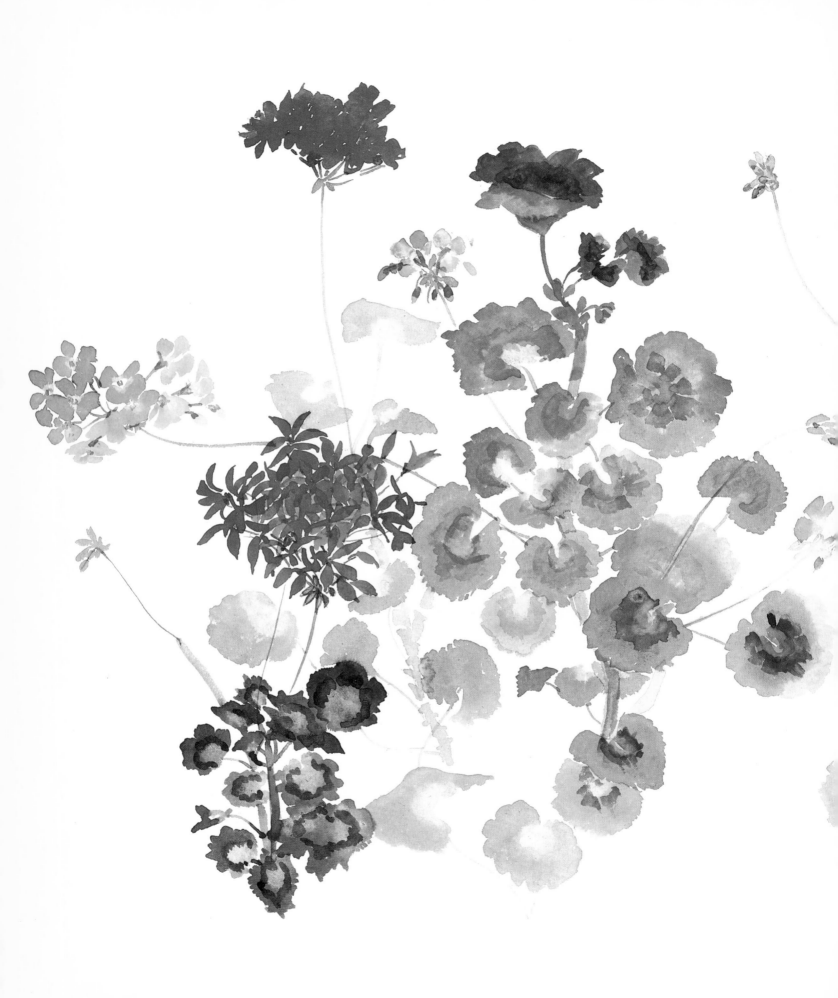

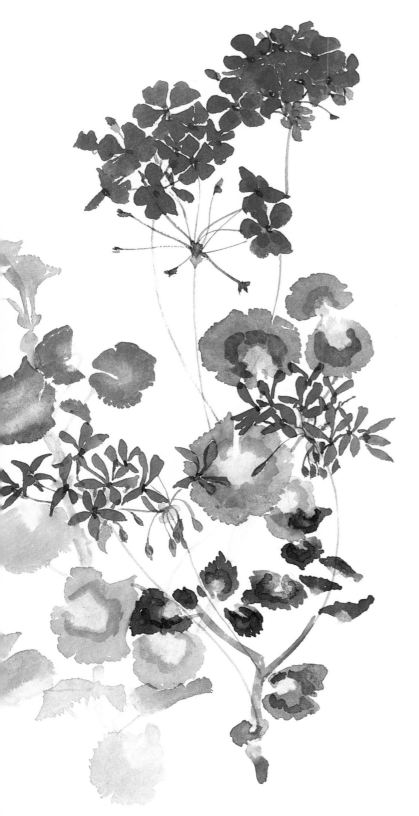

PELARGONIUM MIX

Nowadays, many plants formerly familiar as geraniums are categorized as pelargoniums. The traditional formal planting featuring massed reds gave an overpowering and unnatural effect. Thankfully, the plants are now used more imaginatively in mixed contexts, with bright reds providing welcome, brilliant colour accents. The plethora of new hybrids, both double and single varieties, produce flowers in chalky whites, marvellous pinks, mauves and quite different reds and clarets. Many have intriguingly patterned foliage with leaves shaped like oriental fans. All are rewarding to grow, whether in a tub, bed or border, their long flowering season extending from early summer to the first frosts.

The *Pelargonium* genus contains a large number of species, the generic name being derived from the Greek *pelargos*, 'a stork', an allusion to the resemblance of the seed head to the head and beak of that bird. *Pelargonium* species are mostly natives of South Africa, but the species are no longer grown as garden plants, having been replaced by more showy varieties developed from them, of which there are thousands.

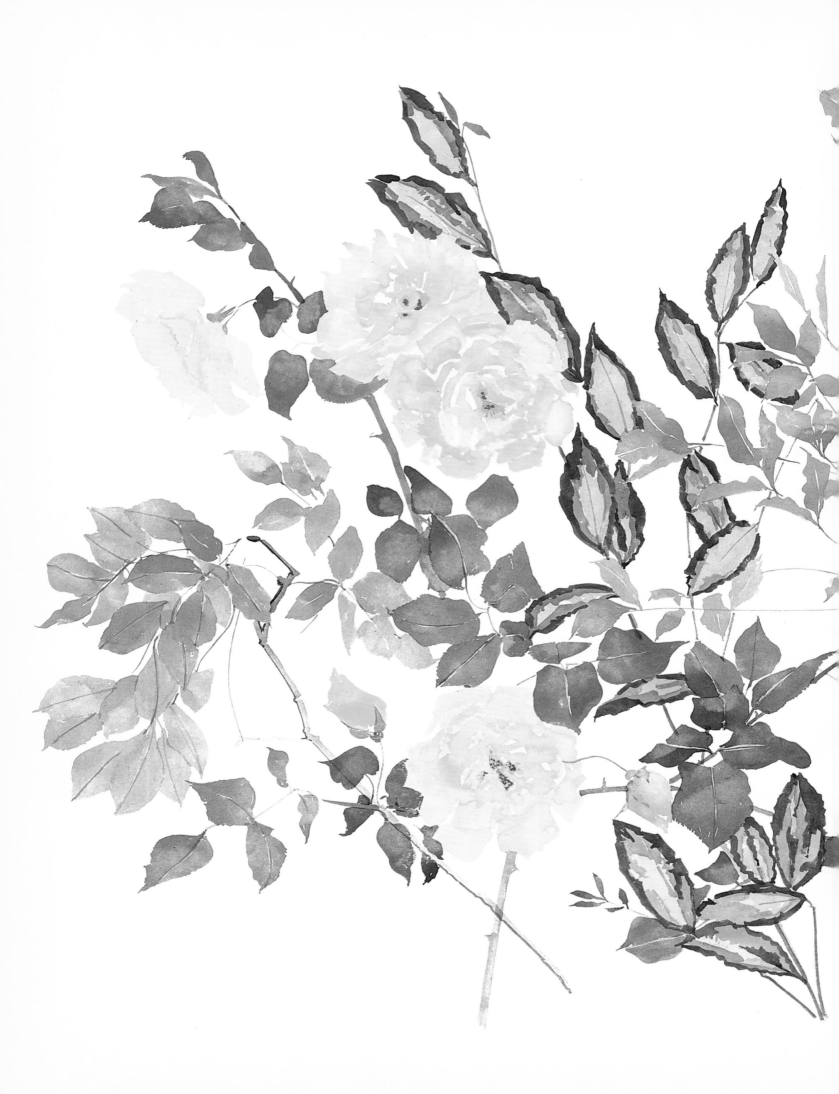

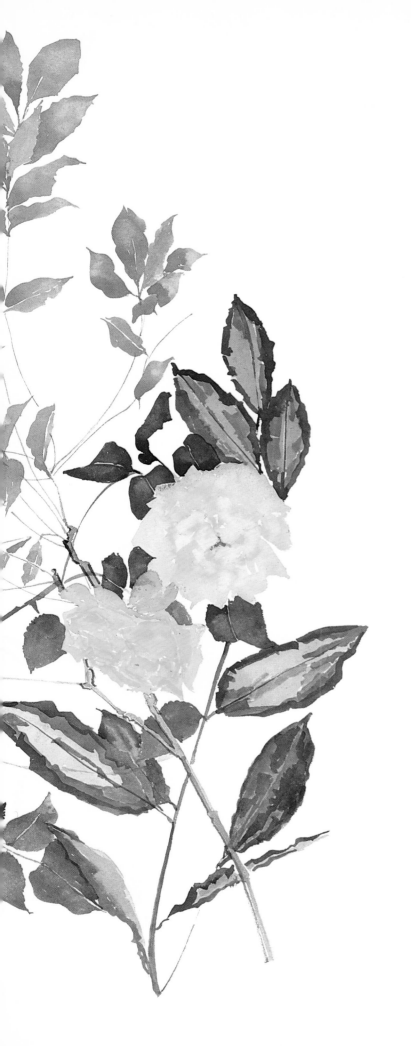

YELLOW CORNER

This grouping of soft yellows happened by accident, the variegated elaeagnus was suddenly encompassed by the climbing rose and the wisteria. The wisteria was the greatest surprise — a white-flowering variety new to the garden that quickly garlanded several bushes. Its first sprays of green leaves suddenly changed to the palest gold, dappling lighter and darker as they moved, creating a marvellous foil for the rigid patterning of the elaeagnus. The roses above seemed to float in the air, exquisitely soft, changing colour with age — sadly a short-lived loveliness.

The members of the genus *Elaeagnus*, of which there are some thirty, are shrubs or small trees mostly from the Far East. Their general common name is the Oleaster or Wild Olive, and the genus belongs to the family *Elaeagnaceae*. Some of the species are evergreen but a characteristic of them all is the covering of the younger parts with silvery or brownish scales. The yellow or whitish flowers, which look like miniature fuchsias, are mostly fragrant. *Elaeagnus pungens var. aureo-variegata* has leaves that are variously marked with deep yellow in the centre, often with paler yellow between the deeper colour and the green.

FIRST OPENING – FREESIAS

Freesias have irresistible appeal, with their perfect trumpet flowers delicately perched on arching stems. Flowering in subtle shades of pink, mauve and amber, they are the essence of refinement; they may be paler or darker but are never garish. Their strong scent — light and fresh with a dry spicy base — is quite unique.

The genus *Freesia* is included in the family *Iridaceae* and comprises a few species only, of which *Freesia refracta* is the most important. The epithet *refracta* means 'bent back', and refers to the bending back of the flowers on the stem. Freesias are tender herbaceous perennials with a bulb-like corm, usually growing to a height between twelve and eighteen inches. The popularity of these plants does not arise from their cultivation in gardens, which is uncommon, but from their adaptability as greenhouse or cold frame plants. They are not difficult to force and, grown in pots, can be used as temporary house-plants for the period they are in flower. They are superb flowers for cutting and highly fragrant, and thus have all the virtues required in a 'florist's flower'.

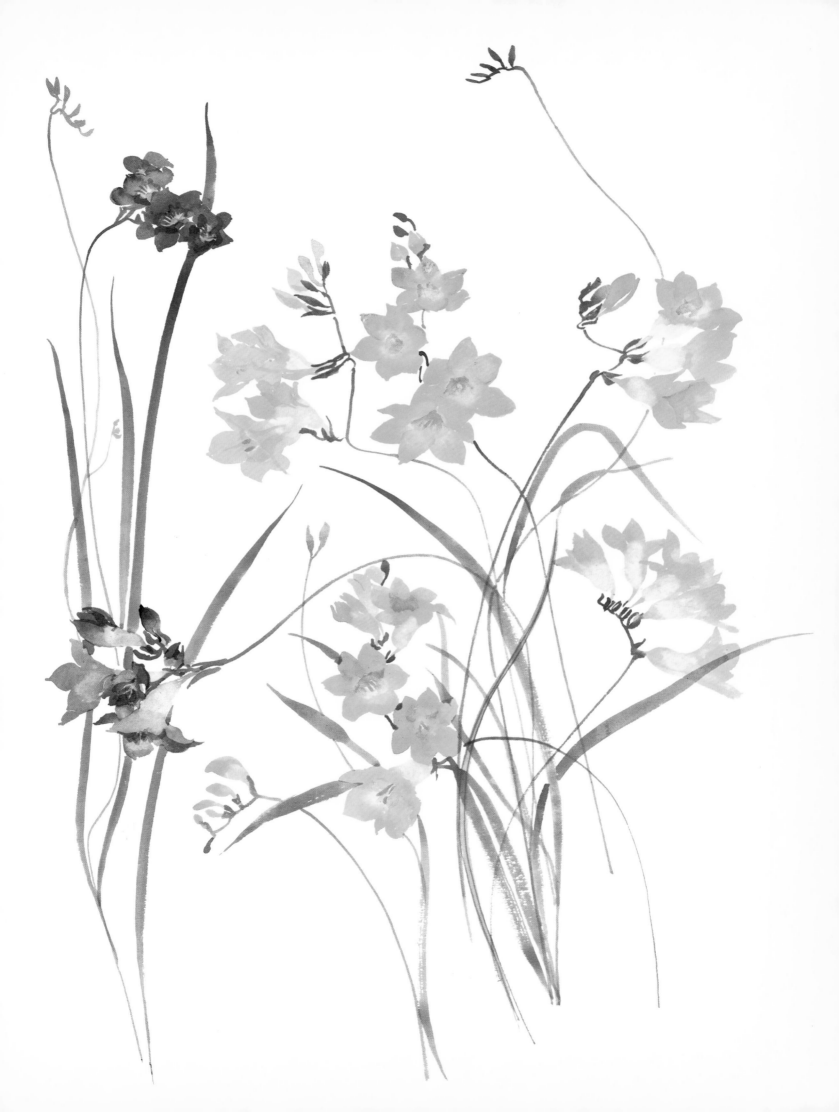

GLINTING GOLD

Even quite late in November the garden can glow with a softly golden suffusion. Those flowers still surviving are especially treasured, as singly or grouped, they sing out amid autumn's gradual darkening. Many variegated shrubs are now at their best, their patterned leaves glinting with gold. Suddenly noticeable, too, are the rich colours of stems, stalks and seed pods, often burnished with gilt and copper.

The 'mimosa' sold in flower shops, and grown in gardens along the southern and south-western coasts of England, is not the true mimosa, which is a different plant, but is *Acacia dealbata*, the Silver Wattle, a name derived from the fine white down which covers the young shoots and leaves. This species is native to Tasmania and Australia. The genus *Acacia* is a large one, containing more than four hundred species, most of which are Australian plants. *Iris foetidissima*, which likes partial shade and a dampish soil, is a native of Western Europe which grows about two feet tall and bears pale lavender-blue flowers amid its attractive leaves in July and August. The epithet *foetidissima* means 'most fetid' and refers to the unpleasant odour of the plant, which has also given it the common name of Stinking Gladwin. It has, however, a compensating virtue: its abundantly produced ripe seed-pods open in the autumn to reveal quantities of large orange-scarlet seeds that are very ornamental.

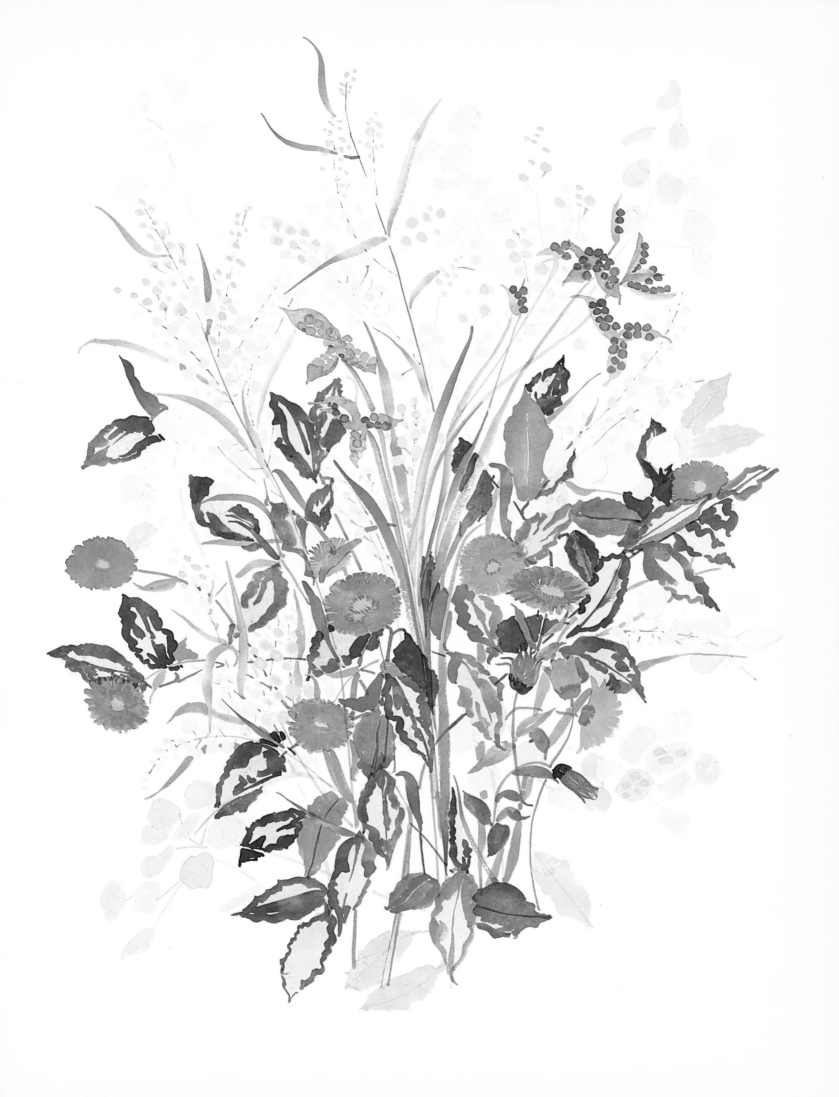

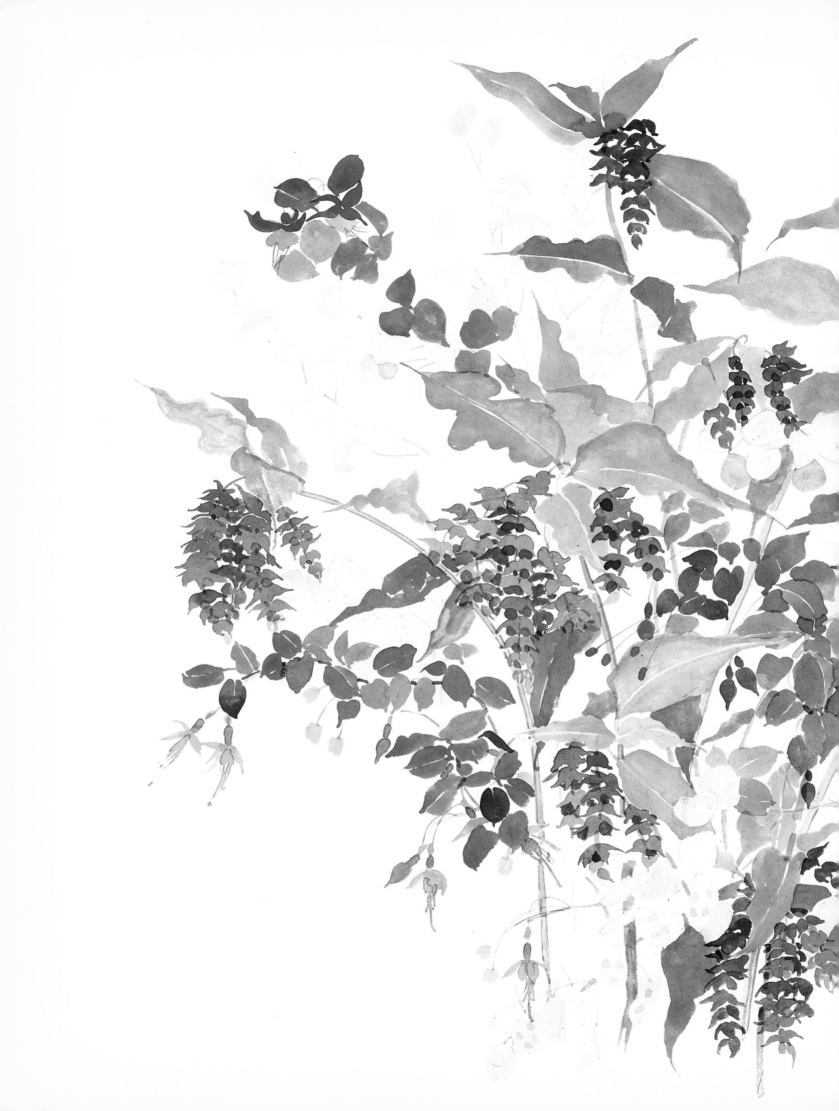

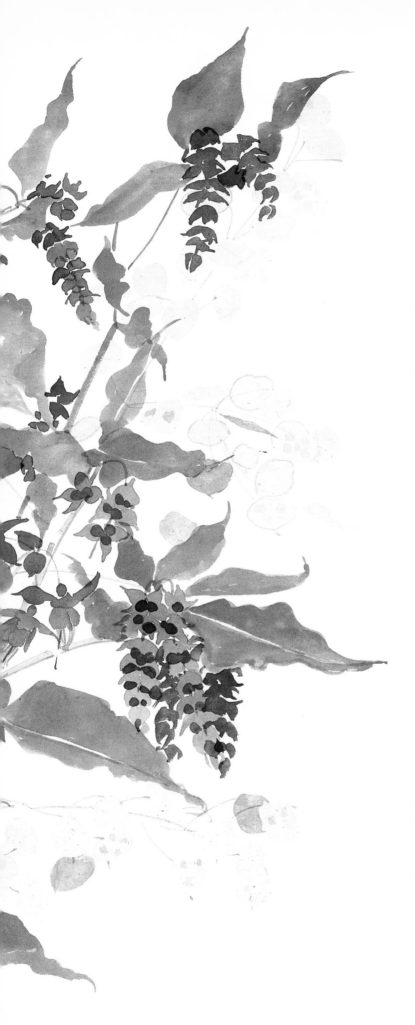

AUTUMN'S HANGING BLOSSOMS AND HONESTY

Leycesteria is frequently referred to more romantically as the Himalayan Nutmeg Tree. It is not widely known and certainly excites curiosity. Quickly growing into a sizeable shrub, the bamboo-like stalks bear soft green, elongated, heart-shaped leaves, like wings. It blossoms prolifically with tassels of port wine-coloured bracts that enclose small white tubular flowers followed by aubergine-coloured fruits — a great temptation to the blackbirds, who eat them voraciously.

Leycesteria is a small genus of the family *Caprifoliaceae* limited to three species only, natives of the mountain forests of Himalayan India, Assam and China. The species grown in gardens is *L. formosa*, the *formosa* meaning 'handsome'. Although a native of shady forests, *L. formosa* prefers a sunny position in the garden and the bracts and fruit colour better in such a spot. The generic name of *Lunaria*, borne by Honesty, is derived from the latin *luna*, the moon, and refers to its round and silvery moon-like seed vessels. *Lunaria* belongs to the family *Cruciferae*. The seed vessels have been popular for decoration since medieval times.

GOLDEN LIGHTS

*Plants newly blooming as summer ends do so in sun-associated colours.
The rudbeckias are prominent, whose flowers appear to reflect the sun
itself, and, filled with its light, shine out with a special fire. Grouped
with other flowers in hot yellows, oranges or siennas, they have an
amalgamated brilliance that echoes the bright gold light before sunset.*

The genus *Rudbeckia*, the Cone Flower or Black-eyed Susan, is a member of the family *Compositae*. Its name
is derived from Olof Rudbeck, a seventeenth-century Swedish botanist. There are about twenty-five
species in the genus, all native to North America and generally found in sandy meadows and damp soils
of almost any type. They are perennial in nature but hybrids have been developed which, as they will
flower the year of sowing, are grown as annuals. The flowers of some of the species are quite large, but
those of the hybrids are larger, up to seven inches in diameter, generally with a darker eye. Rudbeckias
are very weather-resistant and flower on long into the autumn, almost to winter. Montbretia is now
classed in the genus *Crocosmia* of the family *Iridaceae*. The name Montbretia is therefore really a common
name for a hybrid between *C. aurea* and *C. pottsii*, although, to confuse matters further, gardeners often
call *Crocosmia* by the name of Tritonia.

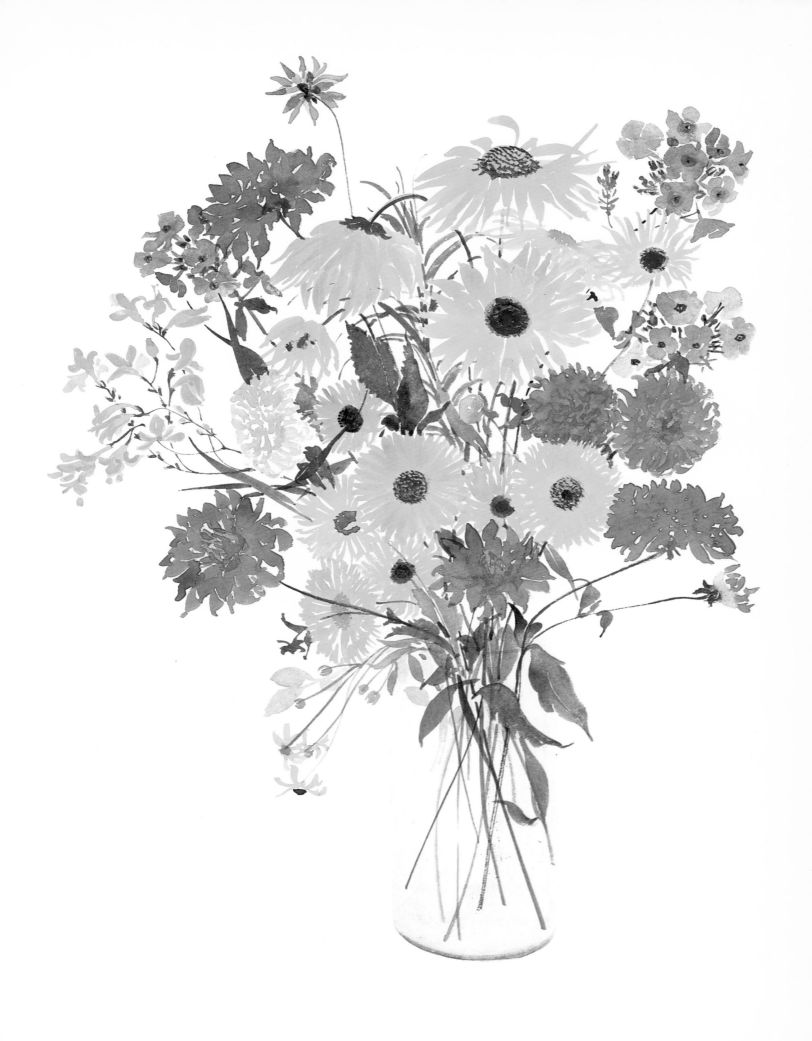

CYCLAMEN –
BIG AND BOLD

The cyclamen's transformation from its miserable,
shrivelled corm, while not instantaneous, is
certainly rapid. No sooner do the noses of the
worm-like shoots poke out than, hey presto, there's
a thick mass of umbrella leaves. Overlapping, they
keep the corm dry and shelter the tender flower buds
that push through to unfurl in stunning colours,
shades of pink, mauve and fuchsia red. The flowers
topping their fleshy stems are elegantly poised, with
a hint of swan-like disdain.

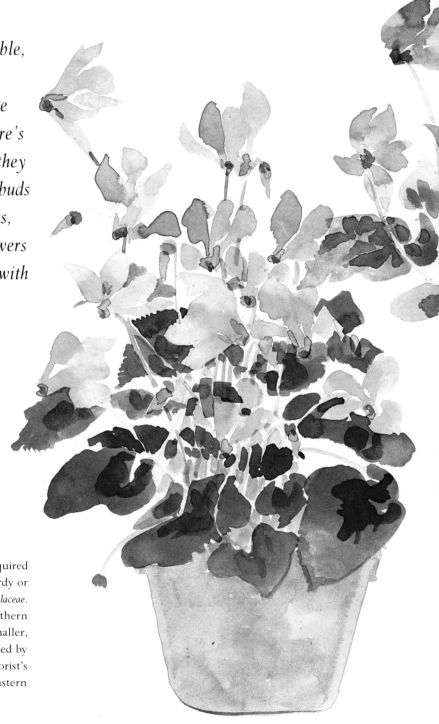

Cyclamen has the inharmonious common name of Sowbread, acquired
because pigs seek them in the woods like truffles. It is a genus of hardy or
half-hardy tuberous-rooted perennials belonging to the family *Primulaceae*.
There are some fourteen species, all natives of the mountains of southern
Europe and the Mediterranean region. Gardeners know the smaller,
hardier varieties, only a few inches in height, which are greatly prized by
the connoisseur, but the only cyclamen known generally is the florist's
cyclamen, hybrids developed from *C. persicum*, native of the eastern
Mediterranean and the Near East, which is not hardy.

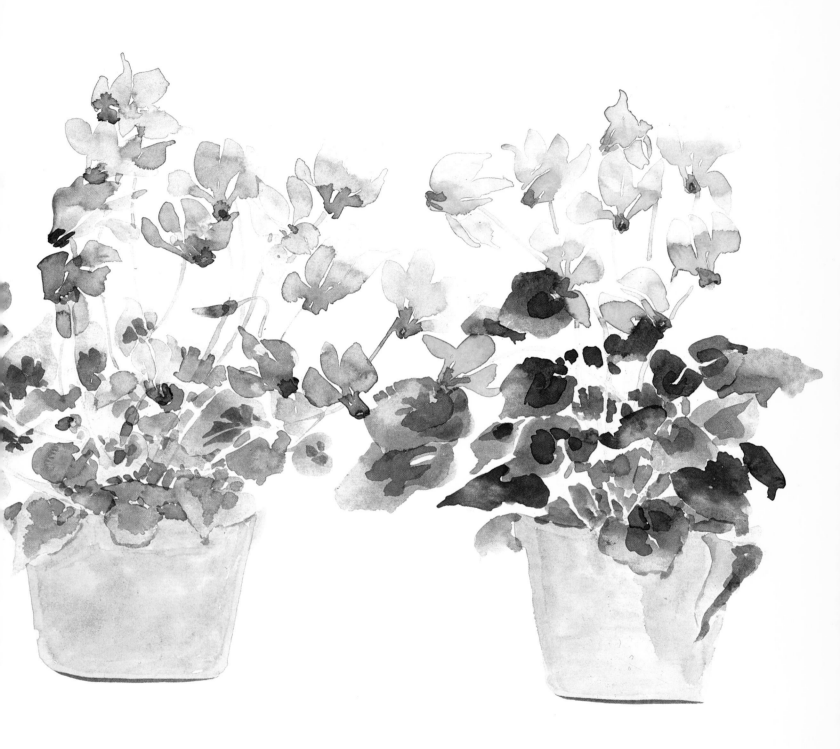

HARLEQUIN MIX

Carnations and freesias, grown in a cold greenhouse and combined with early outdoor narcissi make a splendidly quirky combination. These pinks, purples and whites, in a variety of different shapes counter-change to create a truly Harlequin effect.

These carnations, with their long, narrow, silvery leaves and hard, noded stems are the sophisticated end-product of many years of intensive cultivation and breeding of *Dianthus caryophyllus*, a native of Europe. The name *Dianthus*, is a combination from the Greek of *dios*, a god or divine, and *anthos*, a flower, the 'divine flower', a designation which indicates the esteem in which the genus *Dianthus* has always been held. The epithet *caryophyllus*, which is derived from the old name of the shrub from which cloves are obtained, refers to the clove-like scent which is a distinguishing quality of this flower, and which gives it its common name of Clove Pink. The *Freesia* is a native of South Africa. A plant with ribbon-like foliage growing from a small corm, its flowers have an exquisite fragrance.

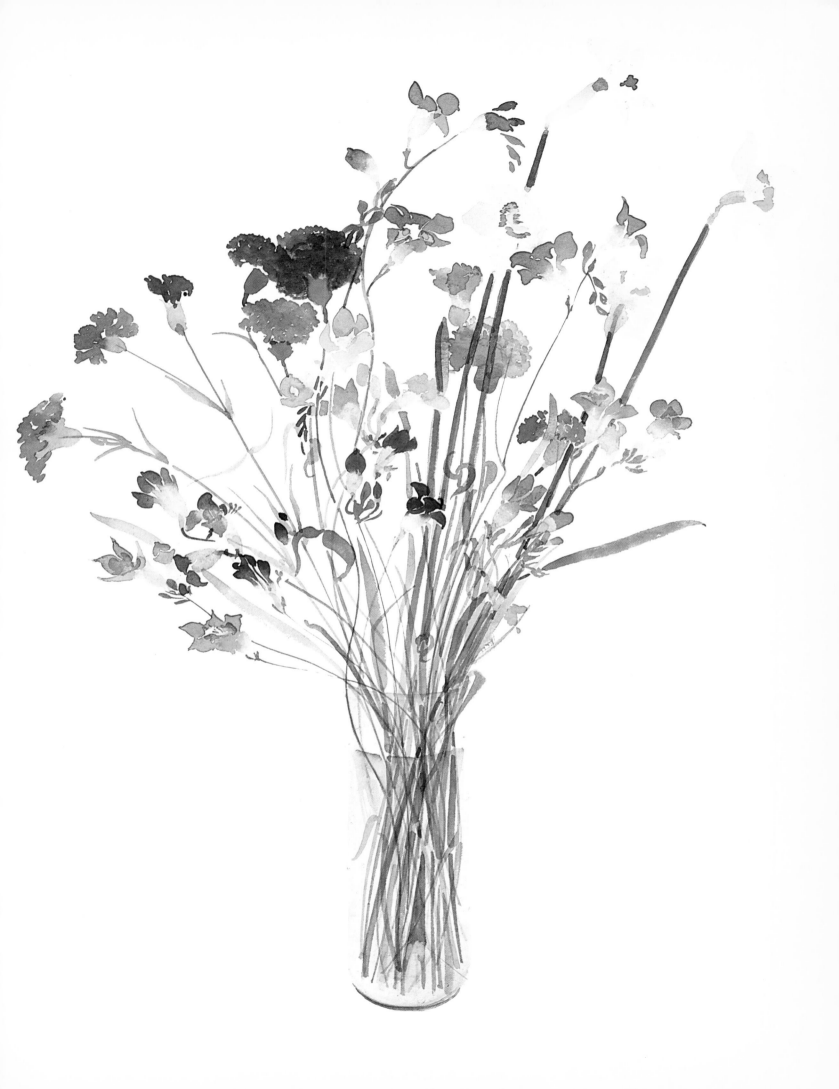

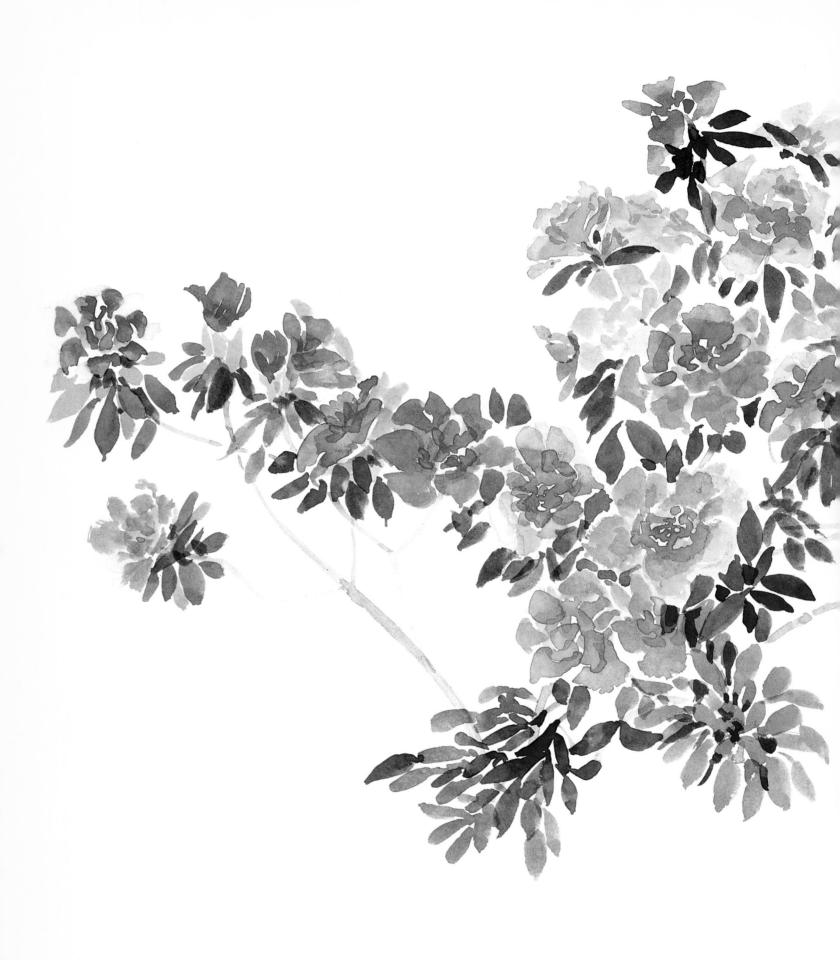

EASTERN AZALEA

It seems so right that the azalea is now classified as a rhododendron, a name that derives from the Greek for rose and tree. Truly exotic in flower, the fragile network of branches is so weighed down with blossom, the shrub has an air of artificiality — a conceit from the garden of an eastern potentate.

The discarded *Azalea* genus had five stamens and were mostly deciduous, while *Rhododendron* had ten stamens and were mostly evergreen. A large number of varieties have been bred from the former, which came both from America in the West and from the Far East. Those from America have given rise to the hardy deciduous shrubs known as Ghent Azaleas. Greenhouse evergreen varieties derived from *Rhododendron simsii* from the East are called Chinese or Indian Azaleas. The Japanese *R. molle* is one of the progenitors of two groups: the Mollis hybrids and the Exbury and Knap Hill strains. Fifth and sixth groups arise from the Japanese *R. kaempferi* and *R. obtusum* respectively.

POINSETTIA –
E. PULCHERRIMA

My first experience of poinsettias was in New York. As a child, spending Christmas there, I came across a shop crammed with them – an Aladdin's cave of 'live' Christmas decorations, the brightest combination of red and green I'd ever seen. Knowing as I now do, that it's a member of the spurge family and that the red fluorescence actually consists of leaf bracts, provides a more sobering perspective. However, this doesn't diminish the exhilaration of the annual first sighting of that radiant scarlet topping the splendid vivid green – a clarion call for imminent festivity.

The Poinsettia originated in Mexico. Botanically, it is *Euphorbia pulcherrima*. The name of the genus is taken from Euphorbus, physician to Juba, King of Mauritania, in ancient times. It is a very large genus, comprising several hundred species, belonging to the family *Euphorbiaceae*. The epithet *pulcherrima* means 'most beautiful'. In its native home, the Poinsettia may reach six feet in height.

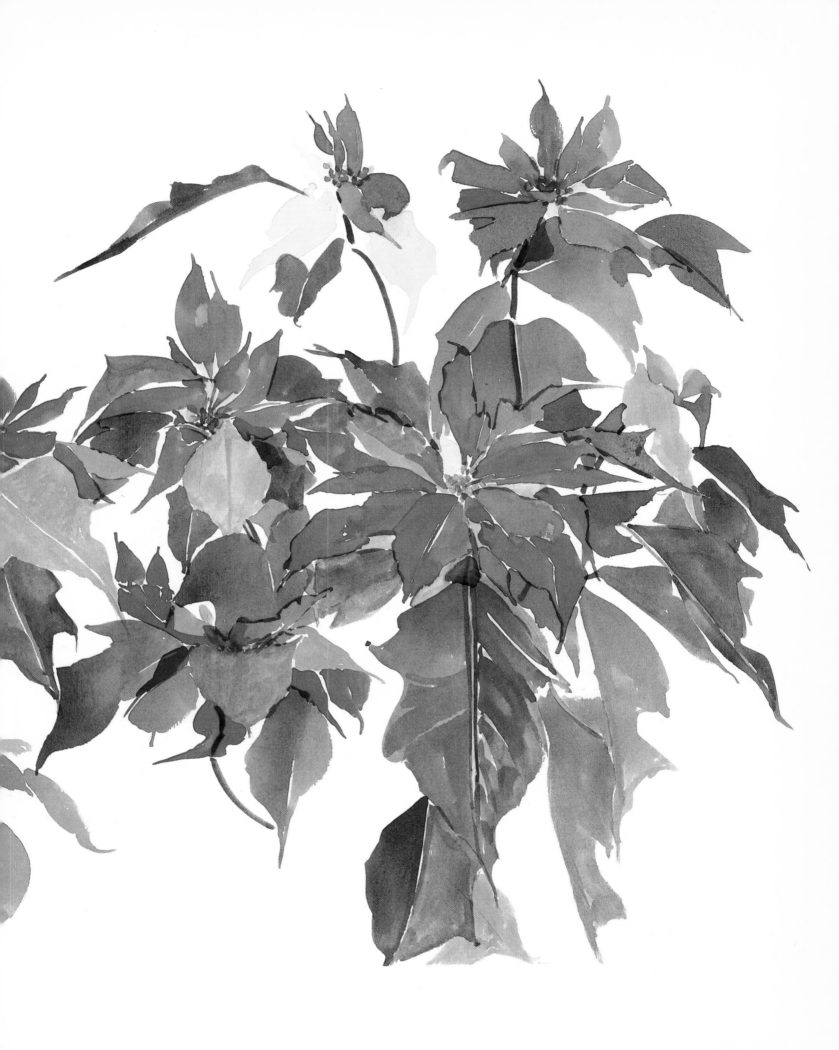

HELLEBORES IN MIDWINTER

Hellebores are the mark of the genuine gardener, being rather strange plants, often with green flowers. This green toning is pervasive, even though the petals can be white, pink or wine-coloured, a quality which can deter gardeners, who might consider it 'unflowerlike'. Such prejudices should be fought, however, as hellebores are rewarding to grow. They thrive in shady places and flower freely when gardens are mostly bare.

The genus *Helleborus* has been known from ancient times and still bears the name given to it by Theophrastus. The meaning of the name is uncertain. Numbers of different species distinguished by botanists have varied, but there are at least eight. They are all erect perennial herbs growing from one to two feet in height. Natives mainly of western, southern and central Europe, they are placed in the same family, *Ranunculaceae*, as the familiar buttercup. Flowering in the winter and early spring, *H. niger* is called the Christmas Rose and *H. orientalis* the Lenten Rose.

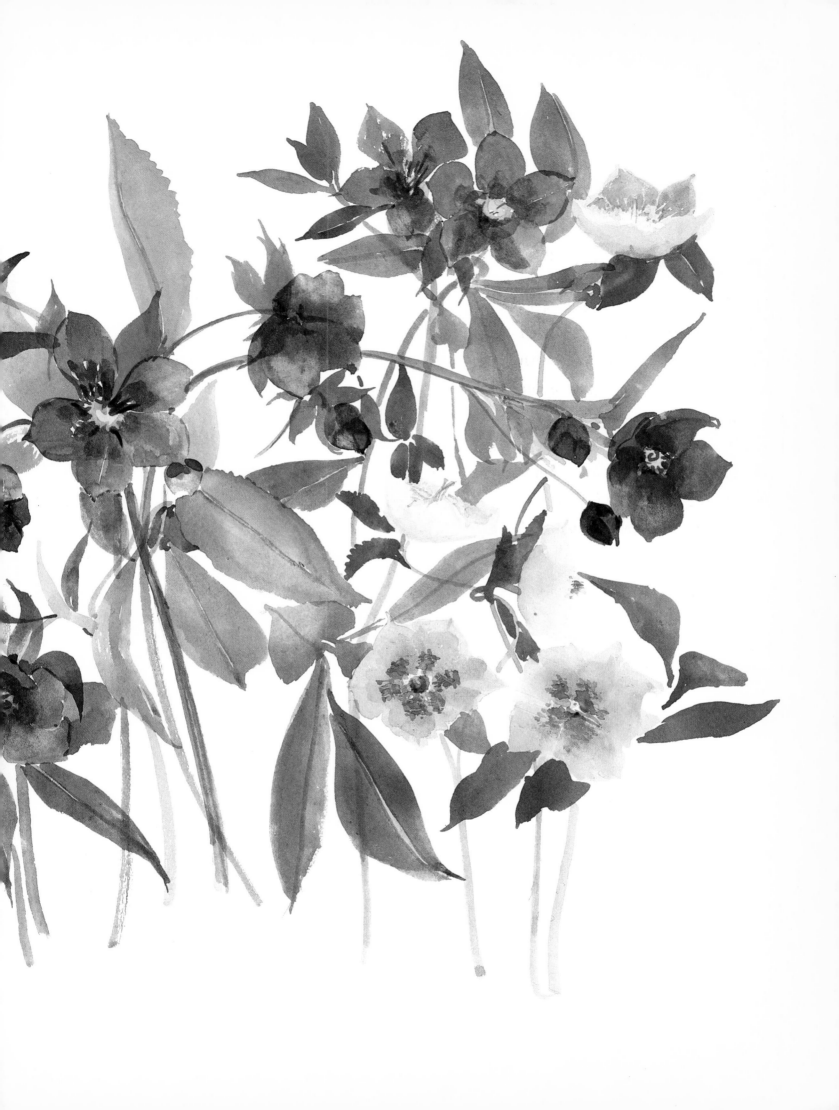

PALE AND PALER CAMELLIAS

Camellias have a detached air. They are distinctively shaped evergreen shrubs, with immaculate, shiny leaves. Budding is unobtrusive, and as this occurs in the year previous to flowering it often goes unnoticed. Subsequently, when the flowers do appear, they seem to do so overnight, giving an instantaneous beauty. In full bloom the camellia is quite wonderful to see as every branch is decked with flowers. Unfortunately their peak is quickly past and the browning as they fade gives the shrub an unpleasant scorched look.

Most camellias in European gardens are hybrids of *Camellia japonica*, but *C. reticulata*, *C. saluensis* and *C. sasanqua* are also grown and used to produce hybrids, of which there are several thousand. A slow-growing evergreen, the camellia can after many years reach the dimensions of a small tree. The camellia was a comparative late-comer to European gardens, enjoying an enormous vogue as a greenhouse plant in the mid-Victorian era of *La Dame aux Camellias*, then virtually disappearing until the early 1900s, when it was revived as a hardy outdoor shrub and has since enjoyed, in its new role, a similar and still increasing popularity. The name of the genus is derived from that of George Joseph Kemel (or Camellus), a Moravian Jesuit who travelled in the East. The tea we drink is derived from the dried leaves of a member of this genus, *C. sinensis*.

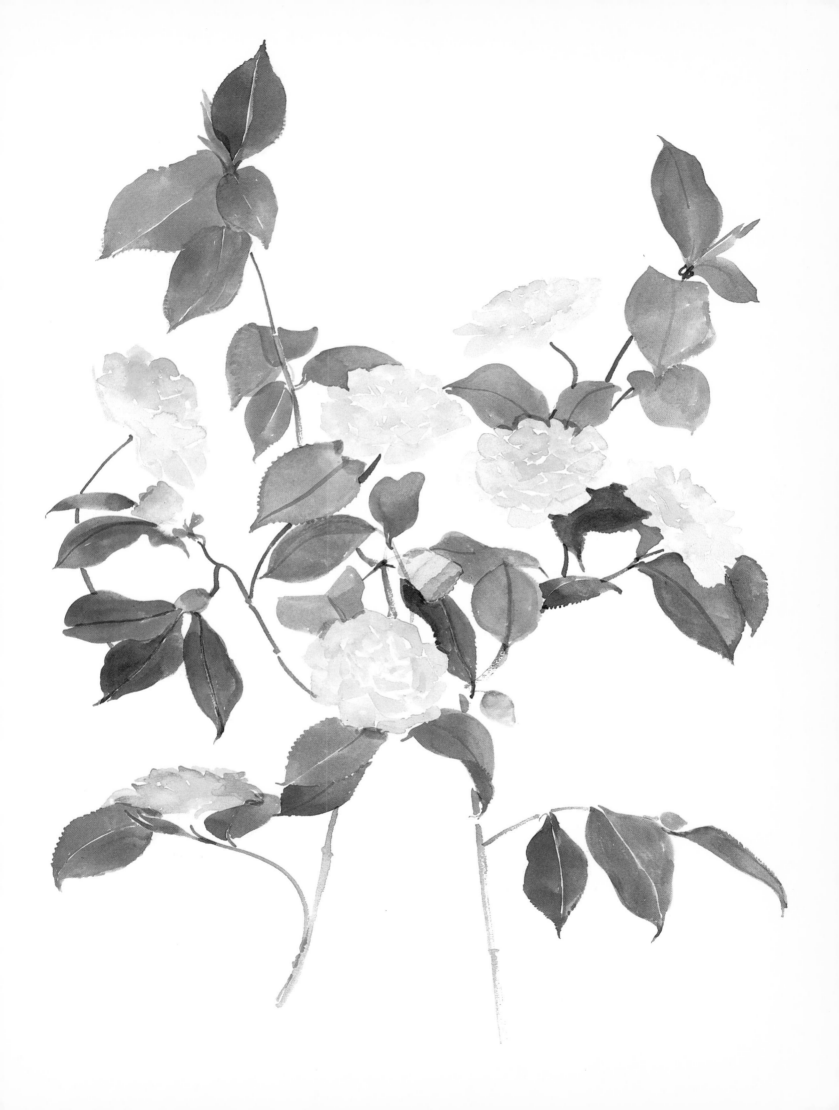

ACACIA SUNSHINE

Acacias form innumerable slender branches, heavy
with foliage, that arch and droop, giving the shrub
a flounced appearance. Each leaf on every slim
stem is minutely detailed, the compound pinnate
leaves growing in leaflets along the central rib, then
subdividing into narrow segments, making a
herringbone effect. Its flowers are dainty — fluffy
balls on tiny stalks arranged in fanning sprays.
Fully out, the shrub is a marvel of floweriness and
exudes a fragrance evoking happy memories
of warm days and clear blue skies.

The plants of the large genus *Acacia*, of the family *Leguminosae*, are so much part of the Australian scene that they have been chosen as Australia's national flower. Their name is possibly derived from the Greek *akazo*, 'to sharpen', many of the species being furnished with spines. Acacias are of very rapid growth and can reach a height of between twenty and fifty feet in their first year. They are, however, easily damaged by wind, and always need a substitute for the shelter that, in their native territory, they find in the eucalyptus trees.

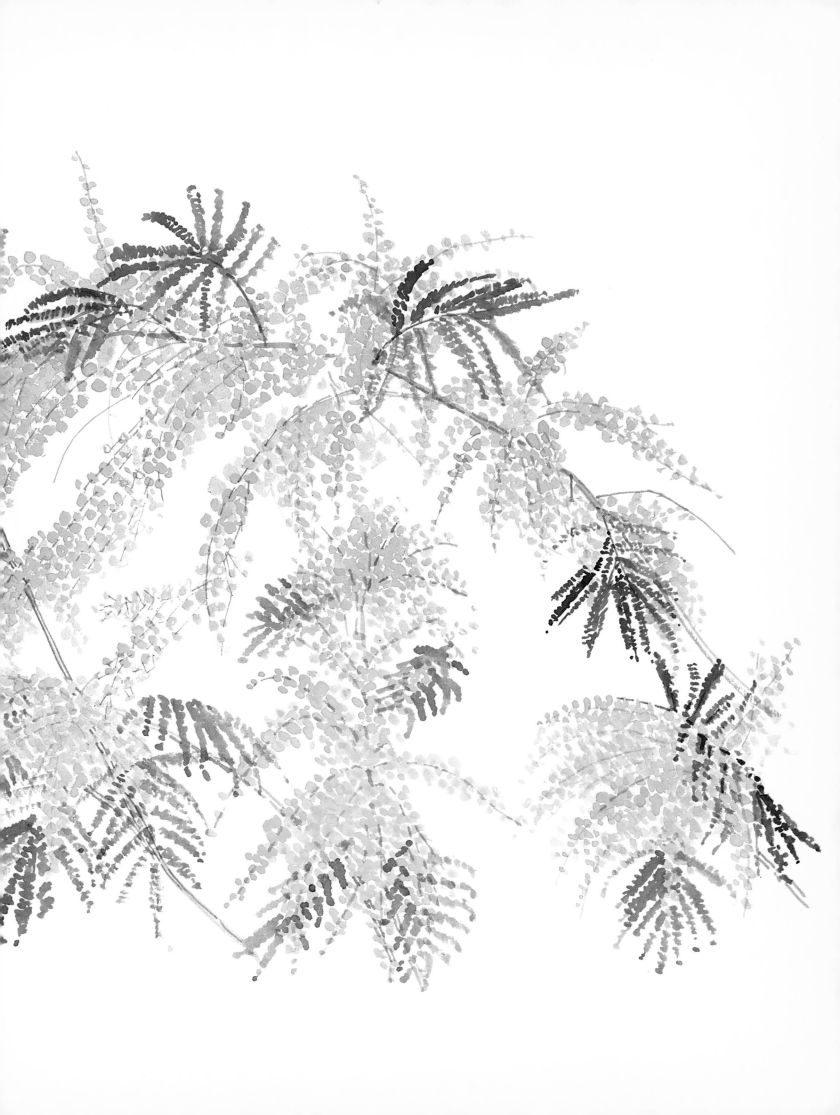

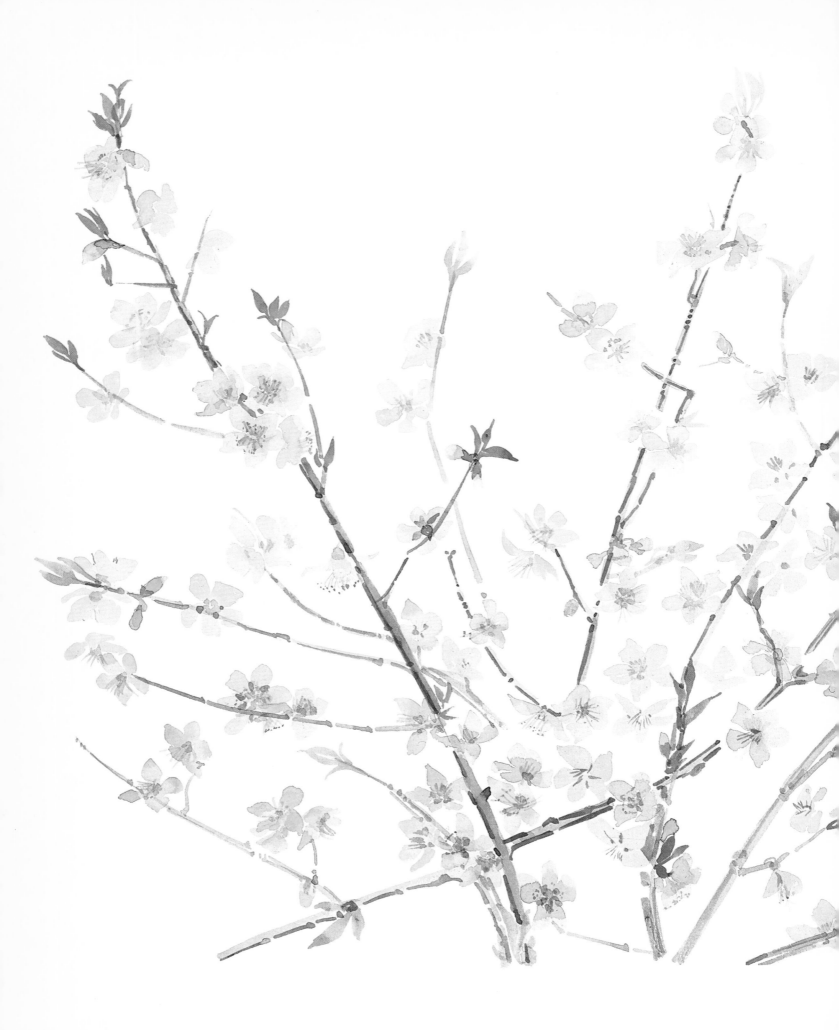

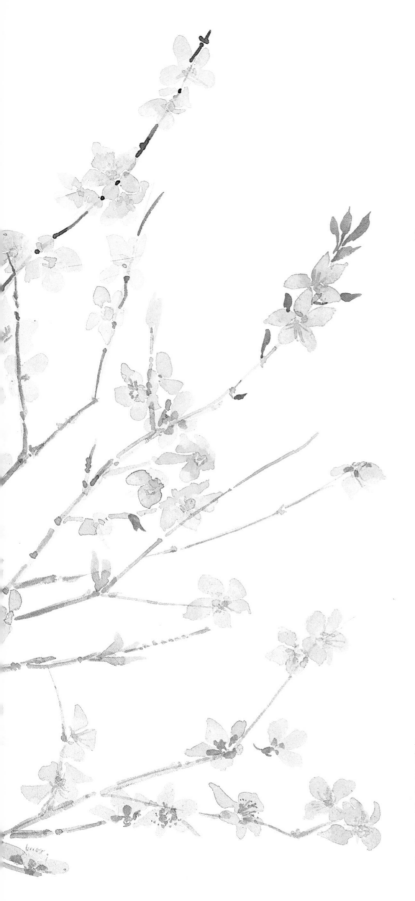

SWEET ALMOND

Sweet Almonds could be our link with Eden since they're mentioned repeatedly in the Scriptures. The Romans cultivated them extensively, decocting the blossom to produce an antidote to drunkenness. Almonds are small, neat, elegant trees — never branching awkwardly or too laden with leaves or flowers. Blossoming when the garden is almost dormant, their slender branches are decked with shiny pink pearl flowers — a marvel to contemplate as one's feet crunch on the frosty ground beneath.

Although a distinction is made between the Sweet and Bitter Almonds, both are varieties of the same species, *Prunus amygdalus. Prunus* is the ancient Latin name for the plum, while *amygdalus*, which means 'lacerated', refers to the fissures in the surface of the stone inside the fruit. The genus is placed in the family *Rosaceae*, its members being distant relatives of our garden roses. The Sweet Almond, *Prunus amygdalus* var. *dulcis* produces the almonds which are used for dessert, while the Bitter Almond, *Prunus amygdalus* var. *amara* produces those which are used in confectionery.

SPRING IS COMING

This assortment, picked at random, is a record of flowers on a January day. The garden's gentle awakening is displayed here in a flowering of the coolest colours, off-white to primrose, mauvey-blue to dark violet. Some flowers appeared as a soft luminescence against the dark foliage of the evergreens. Many newly opened buds exude a fragrance of unbelievable freshness — a pure and uncloying scent that's an unexpected bonus for so early in the year.

The name 'iris' is associated with the rainbow, signifying a mixture of colours, and derived from the Greeks. *Iris unguicularis* is more familiarly known to some as *I. stylosa*. The epithet *unguicularis*, 'narrow-clawed', refers to the shape of the ends of the petals. This species, which is native to Algeria, is scarcely hardy in Britain. It grows about a foot high and its foliage, grass-like in appearance, is rather untidy, but it has the redeeming virtue of being the first iris to flower each year. *Jasminum nudiflorum* is a native of China. Its name means the 'naked-flowered' Jasmine, a reference to its habit of bearing its yellow star-like flowers on branches bare of leaves.

INDEX

PAINTING DIMENSIONS

(Height × width, plate numbers are in italics.)
1,000 × 760cm *26*; 850 × 760cm *17*; 800 × 700cm *46*; 770 × 760cm *50*; 760 × 840cm *18*; 760 × 560cm *Frontispiece, 28, 29, 35*; 765 × 760cm *22, 41*; 740 × 760cm *43*; 700 × 1,000cm *4, 7, 11, 12, 14, 15, 16, 34, 36, 38, 42, 44, 52, 55*; 700 × 720cm *58*; 700 × 500cm *Back cover, 5, 6, 8, 13, 19, 21, 30, 33, 37, 45, 48, 51, 53, 56, 57, 59, 61, 65*; 560 × 760cm *Half-title, 1, 2, 9, 23, 24, 25, 27, 31, 32, 39, 40, 47, 54, 60, 62*; 500 × 700cm *Front cover, 3, 10, 20, 49, 63, 64, 66, 67, 68.*